IMAGES
of America
HOT SPRINGS COUNTY
WYOMING

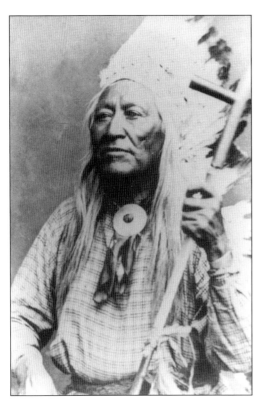

Chief Washakie of the Shoshoni was revered throughout the West for his understanding of the ways of the white man as well as his unending patience with them. Early on he saw the uselessness of fighting a nation of people armed with advanced technology, who so out-numbered the Indian populations. Because of his wisdom, the Shoshoni were able to stay in their favored country.

Sharp Nose of the Arapaho, like Washakie, had served as a scout for the U.S. during the 1870s Sioux campaign; it was said of him that he was chosen as chief because of his leadership in dealing with the Whites. Nevertheless, even he hoped that by performing the Ghost Dance the Whites would be covered by a "Great Cloud."

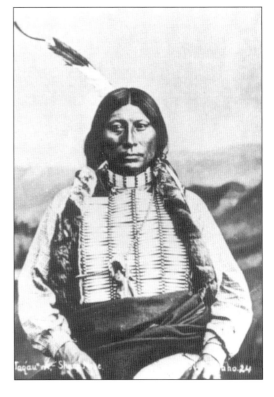

IMAGES of America
HOT SPRINGS COUNTY
WYOMING

Alex Service and Dorothy Milek

Copyright © 2002 by Alex Service and Dorothy Milek.
ISBN 0-7385-2058-6

Published by Arcadia Publishing,
an imprint of Tempus Publishing, Inc.
3047 N. Lincoln Ave., Suite 410
Chicago, IL 60657

Printed in Great Britain.

Library of Congress Catalog Card Number: Applied for

For all general information contact Arcadia Publishing at:
Telephone 843-853-2070
Fax 843-853-0044
E-Mail sales@arcadiapublishing.com

For customer service and orders:
Toll-Free 1-888-313-2665

Visit us on the internet at http://www.arcadiapublishing.com

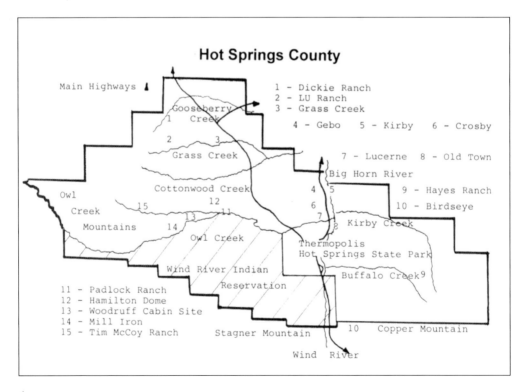

Contents

Acknowledgments 6

Introduction 7

1. The Hot Springs 9
2. Agriculture 27
3. Transportation 45
4. Law and Outlaw 61
5. The Mining Towns 73
6. The Oil Camps 89
7. Thermopolis 101

ACKNOWLEDGMENTS

The authors wish to thank the Pioneer Association. Without the Association and donors, known and unknown, there would be no Hot Springs County Museum, and no photos upon which this book was based. Of special note are the albums prepared by Nellie Wales and Minnian Richardson, and the photo collections of C.L. Jones, the Hayes family, Minnie Brown, Arlene Gaylor Robinson, the Potter family, the Padlock Ranch, John and Betty Trusheim, and Richard Janich (Jovanovich). Other known donors are Harris and Jo Swartz, Clyde Duncan, Henry Jensen, Dan Healy, Shirley Smith, Allan Fraser, Reba Northway, Sig Nelson, Catherine Pope, Mabel Granger, Nan Jones, Wertz Hancock, Cal King/Buck Bunch, Charley Dockery, Dorothy Snyder, Velna Hilliard, Natalie Sherman, Beulah Miles, Ruth Burrows, Jessie Short, Eleanor Hopcus, Wallace Sande, Nellie G. Hodgson, John Harper, Esther Virgin, Mrs. R.J. Rhodes, Helen Cabre, Myrtle Peoples, Joe P. Legocki Jr., Roberta Halbert, Lester Rae, and Peggy Harrington. Thanks also to Butch Schweighart, Landis Webber, Dorothy Hruska, Ellen Roden, Ruby Lippincott, Karen Enis, the volunteers at the Hot Springs County Museum, and the Hot Springs County Assessor's office.

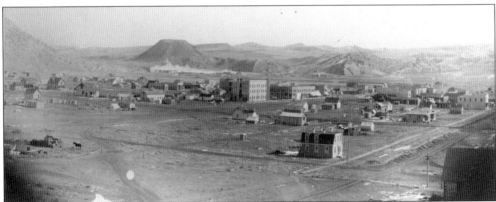

Steam rises from the springs at the foot of Monument Hill in this photo. In the foreground are the buildings of Thermopolis, c. 1906–1910. At the northwest corner of Sixth and Broadway the new Emery Hotel looms over all other buildings. A grazing horse, washing hung to dry, electric poles, the lack of trees, and outhouses at different locations reflect the evolutionary nature of this developing western town.

Introduction

Hot Springs County is nestled in Wyoming's Big Horn Basin. Due largely to its geography, including the once impenetrable Wind River Canyon, the area that is now the county was one of the last regions to be settled during the U.S. 19th-century westward expansion. Because of its isolation, until 1871 there was only transient traffic in the area, mostly trappers and travelers between the Oregon Trail and the Montana gold fields. In many ways Hot Springs County is a microcosm of the elements of the classic "western." It has been home to ranchers, freighters, railroad men, lawmen and outlaws, coal miners and oil field hands. It is also a microcosm of America's image as a melting pot, from American Indians to Scottish sheepherders, from coal miners of Central Europe and Asia to Scandinavian stonemasons. These representative cultures were fairly well-melded by the beginning of World War II. The war brought about major and lasting changes to the lives of county residents. This book is the story of the settlement and culture of Hot Springs County from 1871 to 1940.

The hot springs at what is now Thermopolis, Wyoming, were on the Wind River Indian Reservation, originally held by the Eastern Shoshoni Indians under Chief Washakie. Against Shoshoni wishes, the Northern Arapaho were moved onto the reservation in 1878. All tribes of the region had held the springs sacred due to their healing powers (hydrotherapy). Indians traveling through left gifts at the Big Spring above the Big Horn River. After 1875 white men began to flock to the site. Often in winter they took the steam from the springs for smoke from a huge Indian camp, or worse. As one traveler put it, "It's hell . . . it's hell!" The ailing among them, too, were relieved of pain from various chronic disorders. In 1896 a treaty was signed with the Shoshoni and Arapaho, selling the springs and surrounding land to the federal government, which then turned them over to the State of Wyoming. The state gave leases to various businesses: plunges (swimming pools), hospitals, hotels. However, one-fourth of the water from the Big Spring was to be used in "bathhouses . . . which shall be open and free to the use of the public . . . " along with a free campground. Slowly the "Reserve" developed into today's Hot Springs State Park.

Nutritious, horse-belly high grass drew settlers to the valleys of streams which all run to the Big Horn River. Ranching began at the western end of the county and within 20 years had penetrated to the eastern boundaries of today's county, a county that existed only on paper until its 1913 organization. Water, and the scarcity of it, was the key to all settlement in this semi-arid county. Two large cattle ranches existed on Owl Creek during the open range era, the Embar and the Padlock. They were the major employers in the early days. Many of their cowhands built herds of their own—some legally, some not. Sheepmen and homesteaders

moved in starting in the 1890s. Agriculture was as important to the economy as the springs.

Transportation played a colorful role in Hot Springs County. Stage drivers and skilled freighters, some handling as many as 16 animals at a time, faced severe hazards of weather and mountain roads. This large class of residents, as well as horse ranchers, would eventually lose work after the railroad came in with its little town of Kirby and another stop at the farming community of Lucerne. Automobiles and trucks were the final blow to the horse-drawn economies. Airplanes played a minor role in the economy, as most were privately owned.

Outlaws were among the groups attracted to the "Mecca of the Afflicted," as an early newspaper referred to the town and springs. Notorious characters such as Butch Cassidy and the Sundance Kid were acquaintances of many townspeople, including the mysterious Minnie Brown and Tom Skinner, owner of the Hole in the Wall Bar. There were rumors that some of the most respected entrepreneurs in town did business with the outlaws.

The dust hadn't yet settled from fleeing outlaws when another type of dust was stirred up. Coal had been discovered by freighters in 1898 about 12 miles north of Thermopolis. Other mines soon opened and coal was shipped as early as 1907. But the dust didn't really fly until promoter Sam Gebo came in from Montana. He contacted eastern financiers and their Owl Creek Coal Company grew fast—too fast. Some of the filings for it were made in the name of dead men. Mining went ahead despite litigation with the federal government, while Gebo went to South America. The towns of Gebo and Crosby became full-blown company camps. Coal mining on a large scale ended in the 1930s, largely due to problems with the mines themselves and the advent of diesel engines. Rock quarries and a sulfur mine helped the growth of the county.

Black gold brought the next boom, with the first oil wells drilled in 1904. Many producing locations were operating by 1920 and company camps sprang up at both ends of the county, Grass Creek and Hamilton Dome in the west and Black Mountain in the east. Today oil pays 73 percent of the taxes in Hot Springs County.

Agricultural and industrial settlement in unoccupied country led to centers of trade. In the boom and bust economy normal for areas with extractive resources, mining and oil camps come and go. Commerce began at Andersonville, on the east side of the river, and Thermopolis just across from it. Thermopolis moved to the springs after the 1897 ratification of the treaty. Andersonville died, but Thermopolis has held its own due to the proximity of the springs and its status as county seat. The other two incorporated towns in the county are East Thermopolis, adjacent to the springs, and Kirby.

One
THE HOT SPRINGS

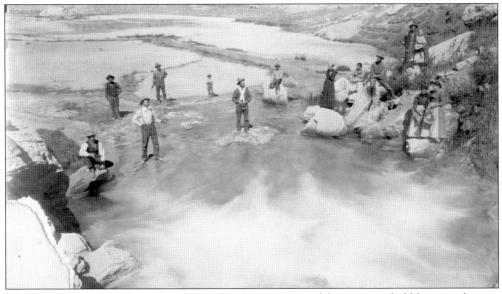

The Big Spring, thought to be the world's largest mineral hot spring, bubbles out close to 18,600,000 gallons of 135 degree Fahrenheit water every 24 hours. Minerals precipitating out of the cooling water become rock-like formations. Indians of various tribes, and then White settlers and tourists such as the Lewis family of Lost Cabin, Wyoming, in this 1899 photo, played in the hot water and used it for medical purposes. Other hot mineral springs are nearby.

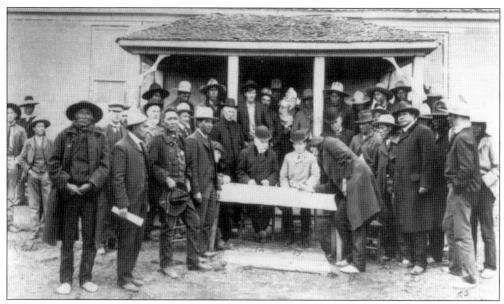

On April 21, 1896, a treaty was signed at Fort Washakie, Wyoming, selling the springs and surrounding land to the U.S. for $60,000. Included among the signers were Chiefs Washakie and Sharp Nose and Major James McLaughlin, who negotiated the treaty. (Courtesy of the Western History Research Center, University of Wyoming.)

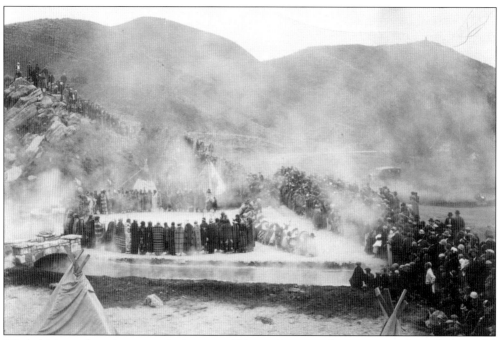

Washakie's words at the treaty signing were, "I have given you the springs, my heart feels good." The Gift of the Waters Pageant, first presented in 1925 and performed annually since 1950, is based on those words. Just as a fall sun was rising over Monument Hill in 1925, Dick Washakie, Chief Washakie's son, emerged through the vapors rising from the Big Spring. He solemnly blessed the water and "gave" it to his white brothers.

One of Chief Washakie's wives is shown here with a baby on her back. Washakie had several wives, including a Crow woman who was a battle prize. He had at least 10 children and was a devoted father, but demanded absolute obedience of his family and his tribesmen. There are two known cases of him meting out the death penalty for men who beat their wives after receiving warnings against it.

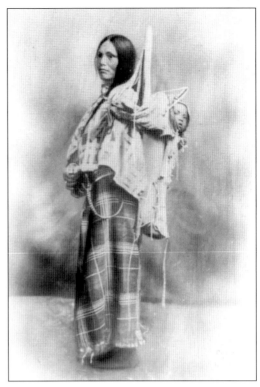

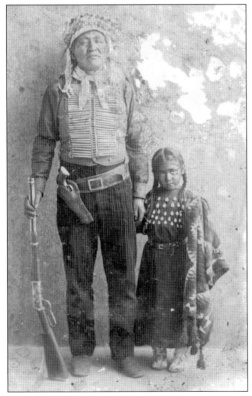

This studio portrait of Chief Dick Washakie holding the hand of an unidentified, solemn little girl in her beautiful elk tooth dress is c. 1910. In 1890 the Commissioner of Indian Affairs had decreed that all Indians were to wear White people's clothing. Fortunately for posterity, this command was not always followed completely. Exchanging shoes for their soft moccasins was one of the small but great hardships endured.

From a treeless, sagebrush-covered flat along the Big Horn River, Hot Springs State Park has evolved into a modern park. Locally quarried stone was used for the work at the Big Spring. To the right of the photo is the site where the Gift of the Waters Pageant is presented each year.

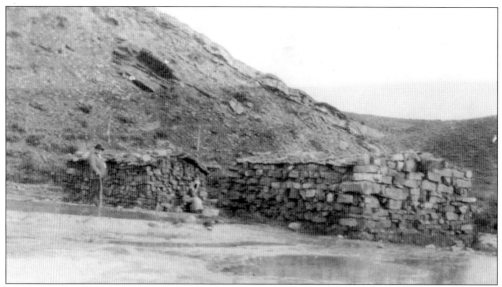

The first bath "houses" were holes dug into the mineral formation and filled with water from the springs. Later, crude stone walls were laid up and covered with canvas, burlap, or poles and sod. These were used from 1889 until 1902 when this photo was taken. The hot water baths were pure bliss—well, not always. Sometimes they were vacated due to the roofs caving in or an unexpected rattlesnake visitor.

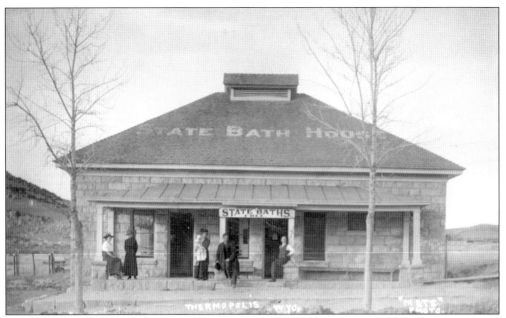

In 1903 the haphazard collection of bath houses was replaced by a dressed stone, state-built bath house, which has since been replaced twice. The Wyoming bill accepting the springs states that "one-fourth of the main spring shall be for use in free bath houses," and a portion of the land set aside for free camping.

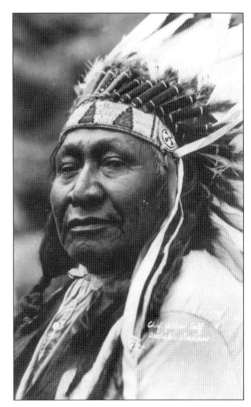

One of the Indians who enjoyed camping and bathing at the springs was Yellow Calf. He did not sign the treaty but became chief of the Northern Arapaho when Sharp Nose died in 1900. Yellow Calf was a widely reputed Medicine Man and Buffalo Caller.

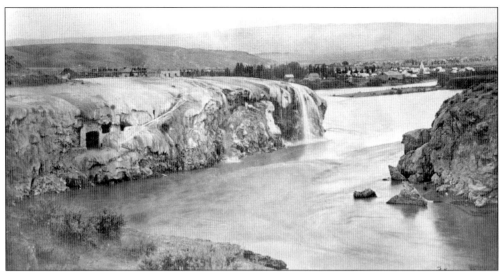

A Mr. Wallace excavated under the mineral water falls, framed a room, and lowered a 4,000-pound water wheel into it in 1899. Mineral water falling from a hole in the roof made it, as far as is known, the first mineral water power plant in the U.S. It failed due to corrosion of the machinery from the minerals and when this photo was taken in 1910, only a hole in the formation remained.

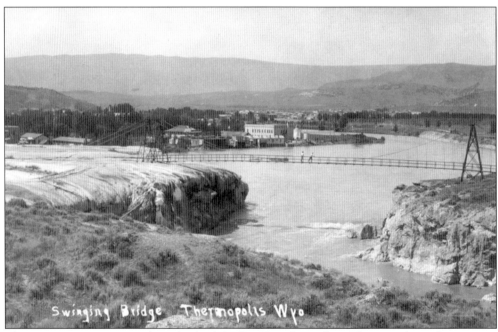

Three suspension structures have bridged the Big Horn River from Thermopolis to the east part of the Reserve, the first in 1895. It fell into disrepair and was replaced by a well-engineered bridge in 1915. The last one was built in 1993. It is possible in this 1920s photo to see the growth of construction in the park as contrasted to the electric plant photo.

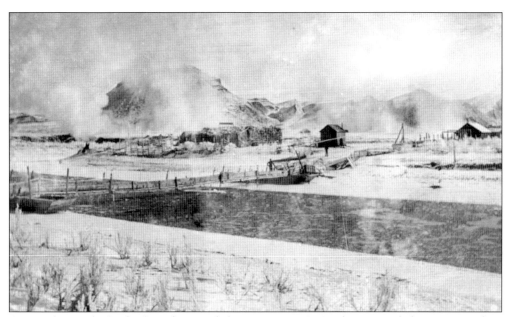

Across this crude footbridge, along with humans, over 5,000 sheep traveled to area ranches. Individuals and businesses built various bridges. Some were free, and some were toll bridges that cost 5¢ a person. In the background is one of the many stables necessary to house travelers' horses.

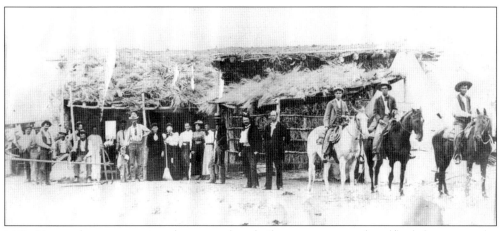

M.D. Gregg, the man wearing the suspenders, built two temporary hotel/bath houses on the Reserve. Gregg wedged huge sagebrush between upright posts and horizontal poles to make the Hotel De Sagebrush, the first hotel on the Reserve. Then he built a frame bath house on the formation, which eventually had to be moved. Finally he and C.C. Weddle built a "permanent" hotel/cafe, the McGannon, near the state bath house.

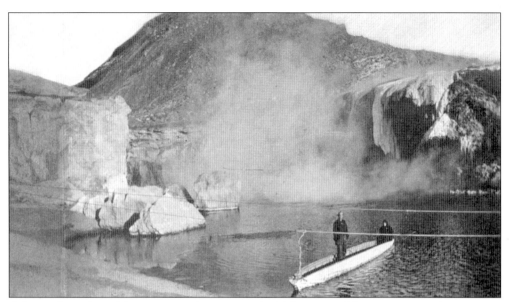

A larger ferry than this was swept downstream in high water with passengers and a team on board. All were rescued, and this supposedly safer one was built. However, when a family of six visitors tried to cross in it by themselves, it capsized, flipping them into the river. One woman was pulled out by her hair. The rest were drowned, including a mother struggling desperately to hold her baby out of the water.

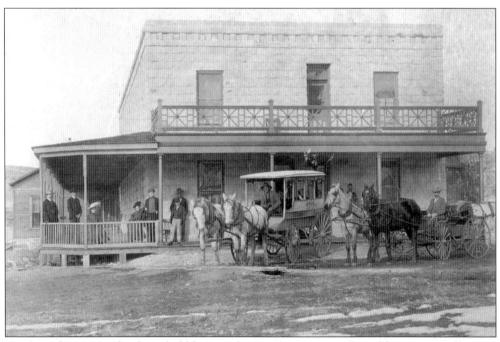

"Driftwood" Jim McCloud was held here at the McGannon Inn after robbing a post office. To prevent a mob rescue or lynching, militia colonel George Sliney handcuffed him to an iron bedstead for five days until the militia could come and move him. "You might escape me," Sliney told him, "but you'll take the start of a hardware store with you."

This interesting structure in the park is the Tepee Fountain, built in 1908 to vent steam from pipes furnishing hot water from the Big Spring to the various establishments. Minerals precipitating out of the cooling hot water eventually caused the structure to change into a huge cone. One visiting professor of geology assured his students that the "teepee" had taken thousands of years to form.

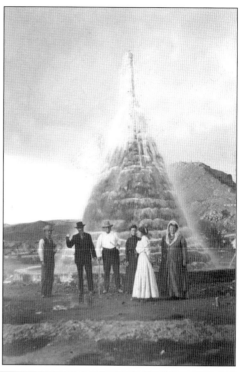

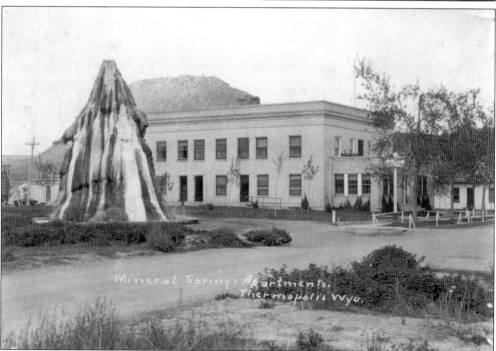

The Tepee Fountain is shown here, c. 1918. The Mineral Springs Apartments were built by A.L. Owen. As a young prospector and miner he was seriously poisoned by a dose of quicksilver fumes in New Mexico. Doctors gave him only a few months to live. He decided to come to Thermopolis to bathe in and drink the water. It did the trick. He died at the age of 84.

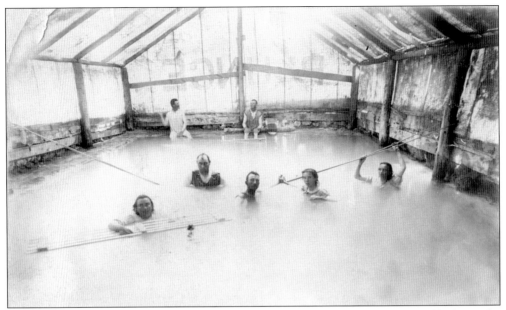

The first plunges (swimming pools), like the first bath houses, were canvas-topped holes in the formation. Here the Lewis family enjoys a swim at the Star Plunge in 1899. The "accommodations" were sometimes drained and used for boxing matches, speeches, and even church services. This led one wit to comment that Thermopolis was the only place in the world where you could take a bath and hear a sermon at the same time.

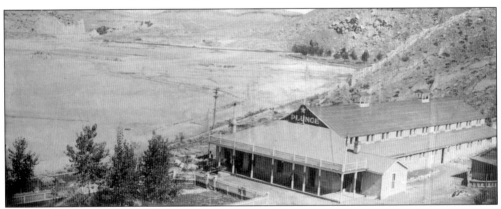

The Star Plunge is the oldest continuously operating business in the park. Gene Garr, who built it, claimed that women and children were safe—the pocket books of his male customers were not. They were robbed of money and watches while swimming. Around 1906, Ed Rohr was given the lease. He held "dance band wars" that drew crowds from all around northwestern Wyoming.

As a lobbyist, Fred Holdrege had obtained a large appropriation bill for the Reserve. In 1915 he was appointed superintendent. A go-getter, Holdrege swept out ramshackle structures, bought new road and fire equipment, and a spotlight system for the terraces. He replaced the suspension bridge, graded streets, installed curbs and gutters and an irrigation system, and set up 99-year leases. He commissioned a $1,000 landscape blueprint along with drawings of an elaborate stone bath house, entrance arch, and casino. In order to obtain appropriations for his grandiose plans, he ran, successfully, for the legislature. He couldn't serve both jobs, so his father-in-law, George Sliney, was appointed as superintendent. Later, Holdrege managed the Washakie Hotel and Plunge. He left for 30 years but returned to live at the Pioneer Home in the park.

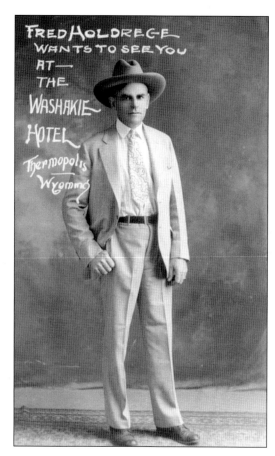

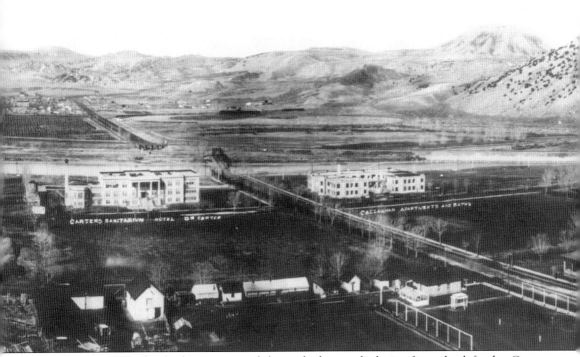

Taken in 1918, this birds'-eye view of the park shows, clockwise from the left, the Carter Sanitarium (built in 1917), the railroad underpass and steel bridge, the Callaghan (Plaza) Apartments and Baths, the edge of the Washakie Hotel, and the superintendent's house with tennis courts, horse barns, and other outbuildings. In the background are the rodeo racetrack, Roundtop Mountain, and Elk/T Hill. Pioneer doctor C. Dana Carter had dreamed of a sanitarium near the springs. Figures for the cost of construction of the building varied from $75,000 to $100,000. On March 23, 1917, the grand opening was held with dinners served by tuxedoed waiters. A tour of the luxurious establishment included 28 private rooms, the billiard and men's recreation room, and the bath and hospital departments. Dancing in the sun parlors topped off the activities. However, too much was spent. Carter's dream turned into a nightmare of legal entanglements until Mr. and Mrs. William Omenson took it over in 1932 and ran it successfully.

For several years it had been suggested that wild animals would be an attraction in the park. In 1914 seven elk were turned loose in a fenced pasture around Elk Hill (now called T Hill for the high school "T" there) on the west side of the river. Later, other elk were exchanged for 16 cow buffalo from the Horne Zoological Gardens in Kansas City. A bull came from Yellowstone. The buffalo joined the elk, along with a huge billy goat. By that time a bear cub had been donated and soon was the biggest attraction on the reserve. The addition of bobcats, badgers, coyotes, deer, antelope, a mountain lion, and other bears necessitated the building of cages on the east side of the river. Today all of the animals are gone except for the buffalo.

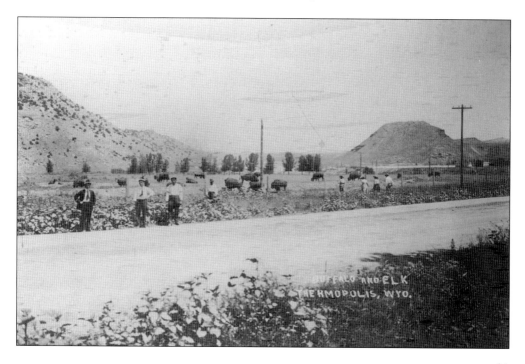

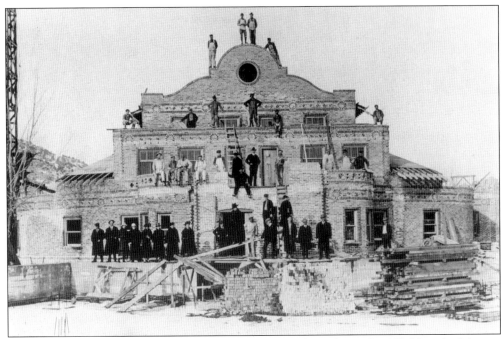

Under construction in 1918, the Washakie Plunge was the only result of Holdrege's elaborate blueprints. As manager, Holdrege opened a pavilion over the unfinished basement. Denver orchestras that played there included Tommy Watkin's six-piece outfit from Elitch's Gardens, and the Herron Girls' orchestra. Dancers waltzed under a large lighted portrait of Chief Washakie. Amateur dance competitions were held and the park became known as the "Joy Spot" of Wyoming.

Twice a week, 50¢ bought a dance and a swim. In July 1935 the popular Arnoldus family orchestra had just finished a waltz when terrible cracking, ripping noises filled the room. The floor disappeared, plunging 75 dancers into the 10-foot basement. The band played on. The crowd remained calm, and injuries were limited to broken bones.

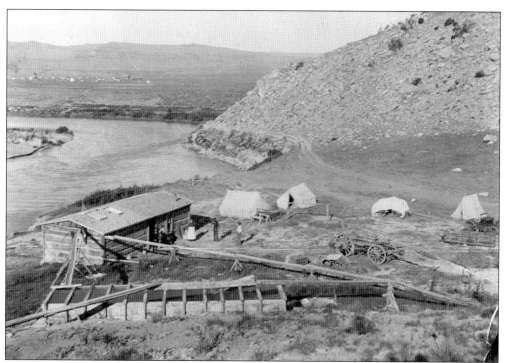

In 1898 Ira Beals of Lander built the Pleasant View bath house near the Fremont Spring on the west side of the river. E.T. Payton, local newspaper editor, wrote that the place was "neat as a pin [but] . . . somewhat crude and the cracks are large enough to stick a led [sic] pencil through." Thermopolis, in the distance, was largely a tent town.

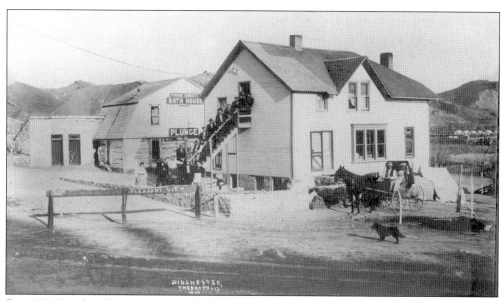

By 1908 Frank Abbott was manager of the expanded business. Medical needs as well as recreation were met at the "Sanitarium." Diners flocked there for Sunday dinner and an afternoon of bathing and relaxing. A cut blasted by the railroad between Pleasant View and the river changed the flow of Fremont Spring, hurting the sanitarium's business.

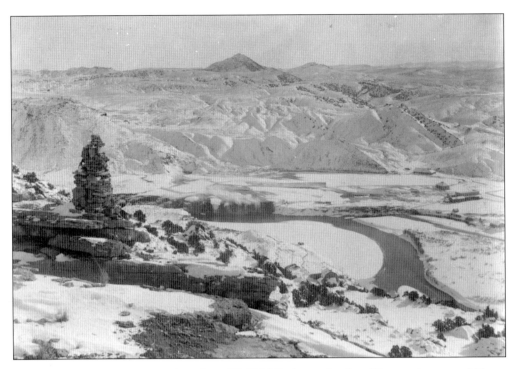

This 1900 winter panorama, taken from Elk/T Hill, shows the Star Plunge, the second Gregg Sanitarium, and an old bath house perched on the west side. Dominating the scene is Black Butte, a landmark east of the park. Due to the water problems, part of the lease above Pleasant View was turned over to Dr. A.G. Hamilton. He opened the Hopewell Hospital in 1918 just in time to treat flu epidemic patients. Towering east of the hospital is Monument Hill. Many visitors who came to the springs crippled took baths and were able to walk to the top of the steep hill where they erected stone monuments. The sign, "Big Horn Hot Spring," has been replaced with a stone one across the hill's face that reads "World's Largest Mineral Hot Spring."

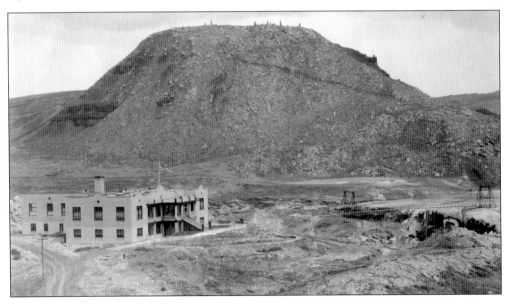

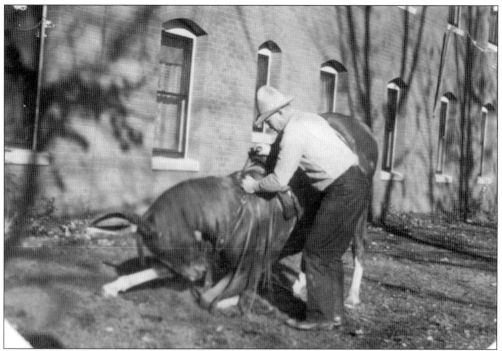

Dr. Carter opened a second hospital on the west side adjacent to the railroad. Carter was one of the earliest doctors in the Big Horn Basin, coming in 1897. A horse aficionado, Carter is shown working by the hospital with his wife's trick horse, Frosty. The Carters had a ranch southeast of Thermopolis.

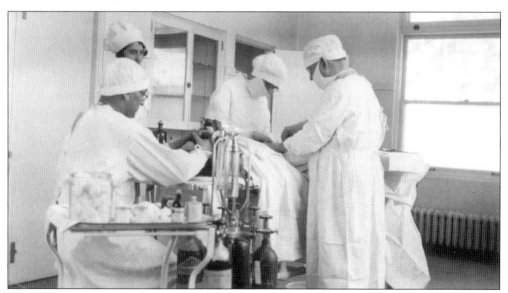

Operating at Hopewell, c. 1920, are Dr. V.A. Mokler, RN Kathryn Hamilton, RN Anna Rooks, and Dr. Hamilton. Kathryn, Hamilton's daughter-in-law, was shocked at their first in-home surgical case. While chickens squawked around, their long-underwear-clad female patient climbed on the kitchen table, jumped down after the first incision, took a swig from a jug, put a record on the Victrola, climbed back up, and the surgery was finished without interruption.

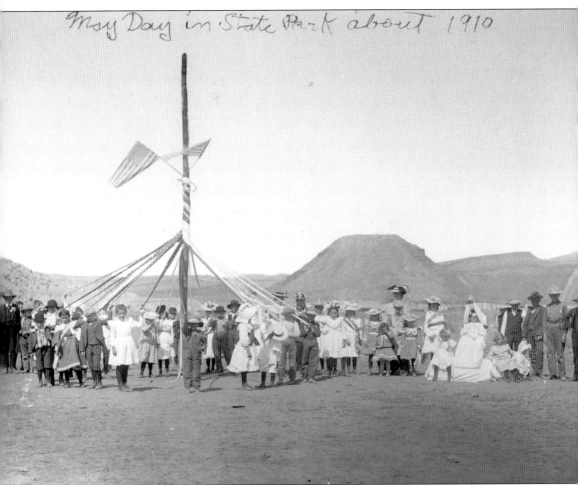

The efficacy of hydrotherapy is found in story after story of patients obtaining alleviation of pain at the springs. Chief Washakie was among them. He received relief from partial paralysis in 1897 just three years before his death at around 100 years of age. As shown in this 1910 May Day photo, the park was a place for fun too. There was no end of contests on which to place "asides" (bets)—boxing matches, foot races, bucking contests, horse races, baseball. Dancing and dining, moonlight strolls along the terraces and falls, swimming, boating, horseback riding, fishing, hunting, berrying parties, excursions to the wild Wind River Canyon, minstrel shows—they all played a part in the good times at the park. Today's experts say that recreation, physical activity, and proper diet all contribute to a person's health. Hot Springs State Park, "the Niagra of the West," offered it all, plus hydrotherapy added for good measure.

Two
AGRICULTURE

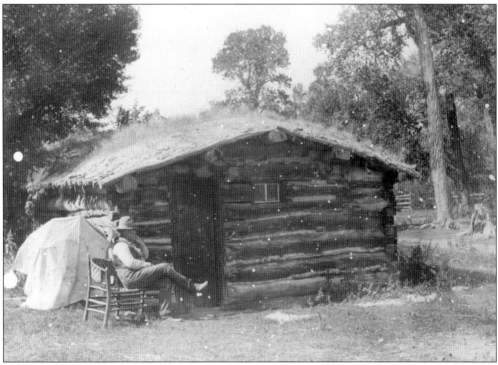

John D. Woodruff, prospector, Indian fighter, miner, and rancher, built this cabin, the first one in the area, on upper Owl Creek west of Thermopolis in 1871. Woodruff trailed in cattle from Oregon, and then sold the cattle, land, and Embar (M–) brand to Captain R.A. Torrey, who was stationed at Fort Washakie. Relaxing in this photo is Robert's brother and partner Colonel Jay L. Torrey, a prominent St. Louis lawyer.

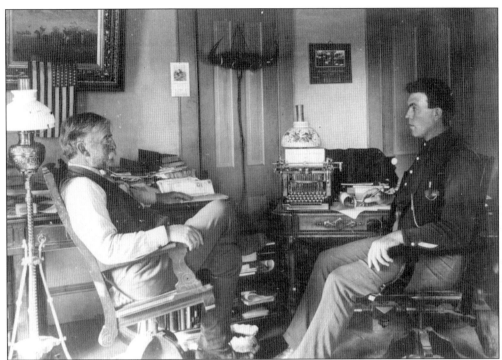

The rude cabin gave way to a fine house where this photo was taken of Jay L. and his secretary, Wallace Hodges. Other mainstays of the outfit were Jacob Price, George "Kidney Foot" Merrill, Vede Punteney, and George Pennoyer. In 1907 the Torreys sold out and Embar became part of the Rocky Mountain Cattle Company formed by Merrill, Gurthrie Nicholson, and L.G. Phelps.

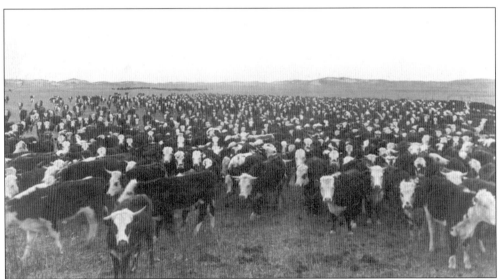

Rough and horned, this 1,000-head herd of Embar cattle is typical of earlier stock. Used to the open range, many cattle died in the ferocious blizzards of 1886–87 when they were unable to paw through the crusted snow to grass, or drifted to find shelter, only to hang up against newly-built fences. There they died of starvation and freezing. Many Wyoming outfits lost 50 percent of their herds. (Courtesy Landis Webber.)

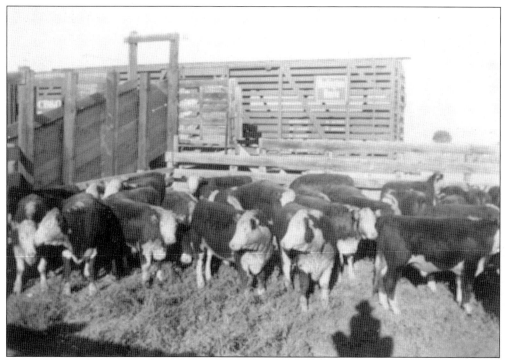

To market cattle between the 1870s and 1906, stockmen had to trail them hundreds of miles over mountains and arid badlands to the railroads, sometimes under the severest of weather conditions, other times plodding monotonously, pestered by dust and insects. Cattle improved and so did transportation. This small bunch of steers is ready to ship from the railroad stockyards at the little community of Lucerne around 1940. (Milek Collection.)

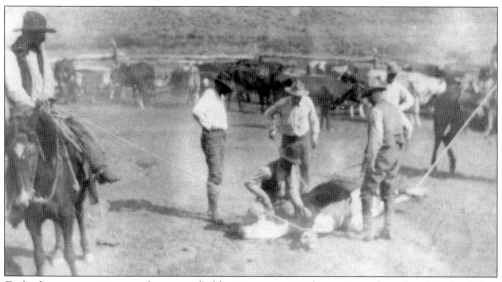

Early-day community roundups were held twice a year, in the spring to brand and in the fall to ship. This branding at the Hayes ranch is c. 1890. Note the pants tucked into the tall boots, something seldom seen on local working ranches today. Ranching clothing and gear evolve depending on the uses they need to serve.

Mabel Nostrum Granger's family homesteaded at Red Canyon west of Thermopolis. Her father and a brother died when she was seven. Her mother supported the remaining seven children by running an eating house at Middleton on Owl Creek. Mabel was an exuberant spirit and loved to dress up, whether in her western duds to ride in a parade, as in this 1908 photo, or in her purple velvet dress and feathered hat to go dancing.

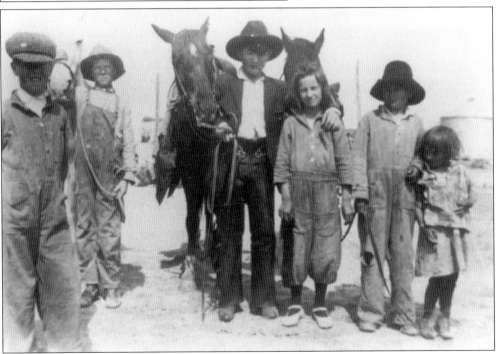

Early day ranch kids "grew up" on horseback. Many of them would saddle a horse to ride a hundred yards rather than walk. These youngsters were no exception. They are Duke Fuller, Dave Picard, Vince "Buster" Hayes, Fran Fuller, Lourie Hayes, and Ruth Fuller.

Good work horses had to ignore loud noises and unfamiliar objects around them. They had to know word commands. Once they learned a job, most were so dependable they could run a delivery route or mow a hayfield with little or no guidance. This 1915 photo is of Louis Bianchi, an Owl Creek rancher.

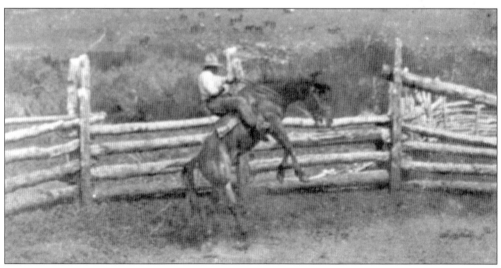

Here is a glimpse of the real West: an early 1900s cowboy bucking one out at the Hank horse ranch on Copper Mountain. There was always inherent danger in a ride such as this. But the cowboys felt they were a lot safer than a subway rider in New York. Horses that liked to buck made unreliable ranch horses but were great for rodeos.

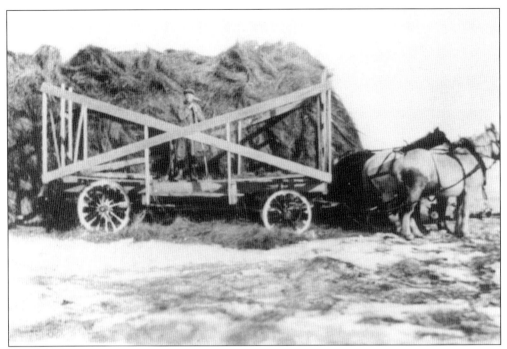

With no open range, cattle could not survive without being fed in the winter. So ranchers started harvesting native grass and raising alfalfa. Not only was hay needed on the ranches, but great quantities were used by feed stables and stage and freight lines. It was all pitched by hand. This fellow at the Mill Iron Ranch is taking a welcome photo breather before loading the hayrack.

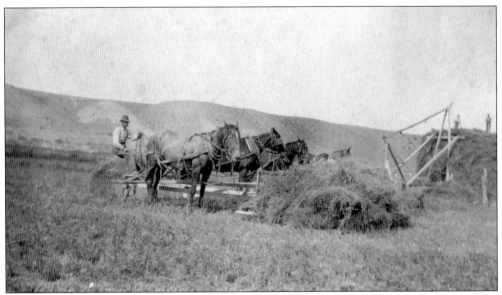

When all went well there was a rhythm to the cycles of haying—mowing, raking the hay into rows, and bucking it to the stacker as this Embar hand is doing. Stacking the loose hay took skill. It had to be laid just right—smooth, overlapping, and humped in the middle of the stack to shed rain and snow.

When Dr. and Mrs. W.A. Winchester celebrated their 69th anniversary in 1933, they were the longest-married couple in Wyoming. Their son, a Nebraska newspaperman, had come to Owl Creek in 1893, $9 in his pocket, and "nailed [his] . . . mast to a cottonwood tree." His parents, siblings, wife, and baby followed. Dr. Winchester had lost an arm in the Civil War and no longer practiced, but Mercy, his wife, nursed many Owl Creek neighbors.

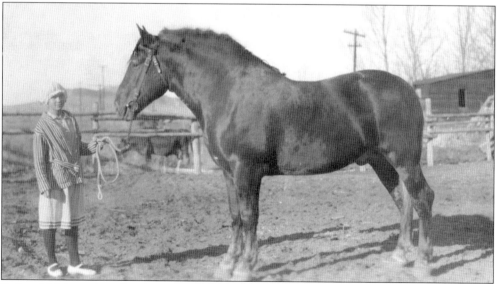

Esther McManigal, at her home in Thermopolis, holds a proud horse, probably Hawthorne Sunrise, a stallion that her father had purchased with other horse breeders in the county. He was also in the horse buying and selling business with hotel man H.O. Emery.

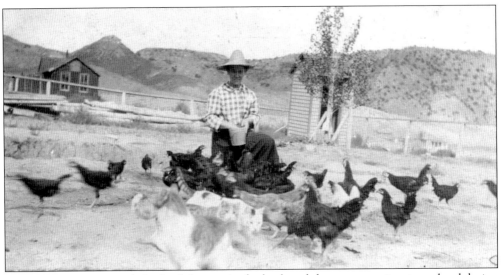

Most pioneer townspeople had milch cows in the backyard that were run in a town herd during the day by young boys. Many residents also kept poultry. "Minnie Brown and family" pose at her home on the north edge of town. Commercial flocks of chickens and turkeys were raised in the rural areas. Note the "convenience" hidden behind the tree.

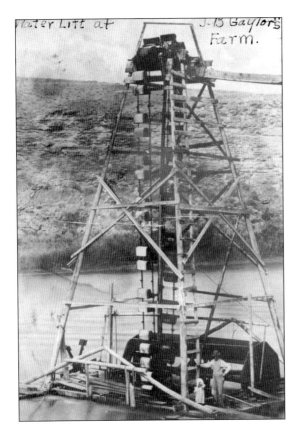

Irrigation was necessary to farming in the semi-arid foothills and valleys of the county. This structure, c. 1910, at the J.B. Gaylor farm north of Hot Springs State Park, lifted water from the river for the Gaylors' dairy herd and for irrigating fields, truck garden, and their 600 fruit trees of 7 varieties, plus 5 types of small fruit. Orchards planted throughout the county died due to drought and winterkill.

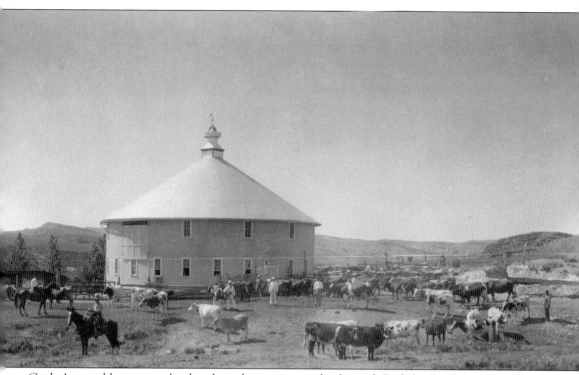

Gaylor's round barn was a landmark in the county until it burned. Built by Frank McManigal in 1914, it housed 40 cows and the loft held 80 tons of hay. A grand barn dance was given to celebrate its finish. At one time Gaylor furnished 90 percent of the milk used in Thermopolis. He had a steam washer and sterilizer and had the first milking machine in the county, as well as what was believed to be the first pit silo in the state. Gaylor offered tomatoes at 1¢ to 3¢ a pound, packed for wagon transportation. When he sold the place in the 1930s he also had a flourishing windbreak of black walnut trees. He, his wife Lumina, and their daughters came to Thermopolis from the Big Horn Mountains where he ran a sawmill. The town was brand new. They spent their first winter in a dugout in Smoky Row, a draw in Hot Springs State Park named for the smoke coming up from the row of dugouts there.

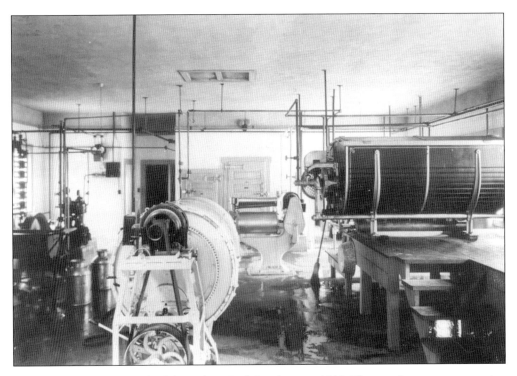

O.B. and Lavere Steward had farmed on Owl Creek since 1913. They took over a cooperative creamery started in 1917. Their knowledge of both sides of the business led to the respect and trust of the producers. The Stewards turned out 6,000 to 8,000 pounds of butter per month. Equipment included a 600-pound-capacity churn, a 300-gallon pasteurizer, and a hydraulic butter printer. Dairying families such as the Gwynns and the Grahams had formerly peddled their products to local coal mining and railroad towns. Milk sold for 10¢ a quart from the back of a wagon, dipped from a 5-gallon can, and poured into containers held by the housewives. Marjorie Gwynn Stump laughingly recalled those days: "Can you imagine what it must have been like on a windy day with the dust and coal slack blowing around!"

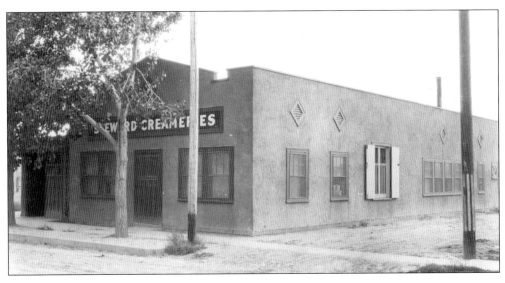

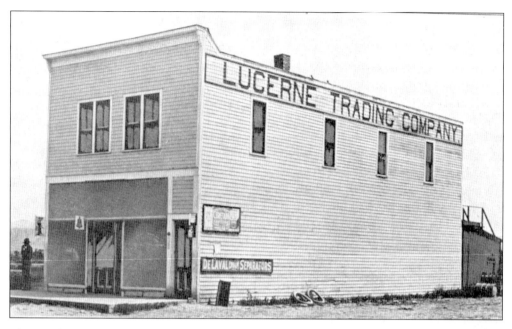

The first homesteaders in the Lucerne valley saw nothing but barren land and sagebrush. Laid out as a railroad town at a strategic road intersection, Lucerne thrived. Besides the trading company, businesses included a lumberyard, coal and ice houses, blacksmith shop, and a boarding house run by Mrs. Jack Shafer, whose husband and a son died in the flu epidemic, leaving her to raise seven children. A school, a church, and fertile farms rounded out the community. Danes, Russians, Swedes, Japanese, Germans, Irish, Hungarians, and Poles lived in the valley. One family recalled prejudice: "We were the Hunkies; they were the Yankees." Nevertheless they stuck together in troubled times. Women, especially, socialized. Teasing husbands called one group "The Cackle Club," even though its function was educational. Photo donor Marie Shafer Walker identified this group only as Lucerne farmers at their beet dump.

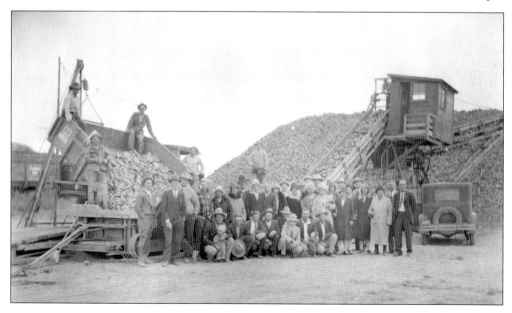

These dapper gentlemen are the Dickie brothers, Scotsmen who had large holdings in the northwest corner of the county. Headed to Canada from southern Wyoming with a flock of sheep, they were accosted and turned back at Gooseberry Creek by armed cowboys. The brothers stayed there, and died wealthy bachelors. Dave is buried in a mausoleum at the remote ranch, and James in Thermopolis, where "my friends can come to see me."

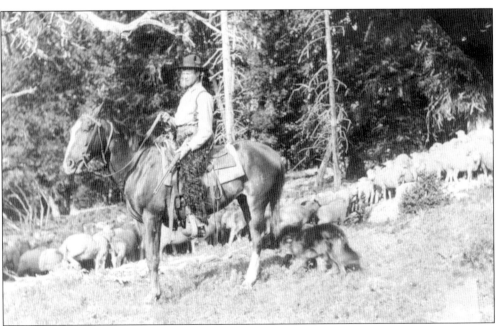

Arthur Hedgecock of Cottonwood Creek is on his way up country with his dog, his horse, a band of sheep, and his rifle, the latter in case of trouble, four-legged or otherwise. Both cattle and sheep were wintered in the foothills and spent the summers in the high country.

Sheep wagons were largely inhabited by bachelor sheepherders, but in the summer, the wagons often housed a family, plus furnished shelter for the family pets. When days were pleasant, the children spent every moment outdoors. When a week of rain set in, one hoped that the little ones had an ingenious and patient mother. One sheep wagon served as a school at Grass Creek.

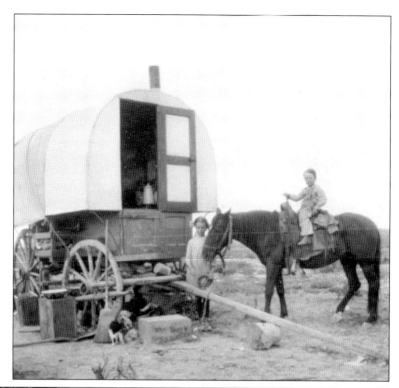

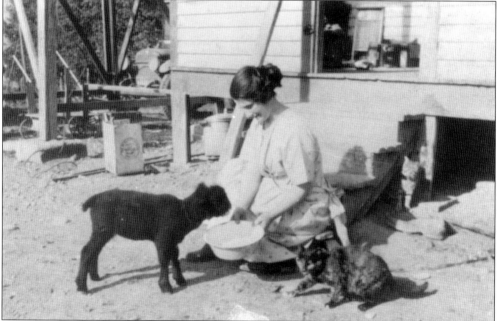

Jesse (Nettie) Fraser feeds an orphan lamb at the Hillberry ranch, 1924, while a kitty hopes to sneak in for a share. Peaceful scenes such as this were not always associated with sheep. Because of deteriorating range conditions due to overgrazing and weather at the turn of the century, relations between cattlemen and sheepmen escalated from tense to violent, from warnings to bullets and the killing of sheep and sheepmen.

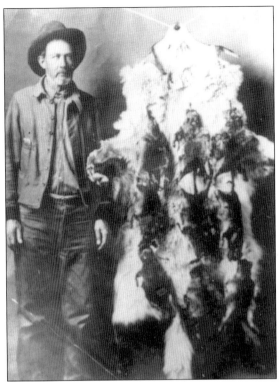

Animosity between cattlemen and sheepmen faded as ranchers diversified and ran both species. Then they fought common enemies—weather and predators. Stockmen who found live animals hamstrung, with their intestines hanging out, bawling in pain, carried on an all-out war against wolves, successfully, and coyotes, not so successfully. Lee Mathers in this 1930 photo with a large wolf hide was a government trapper hired for the battle.

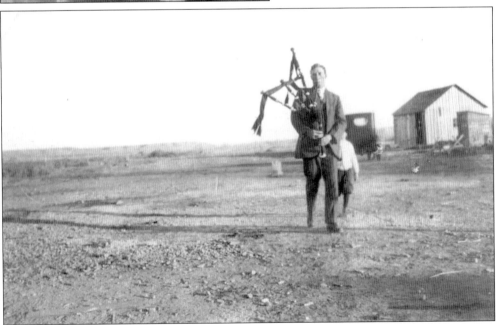

Scotspeople such as George MacKenzie, spelled "Mac" not "Mc" as he was quick to point out, were the rule rather than the exception in the sheep industry. MacKenzie was one of a small group of pipers who entertained on special occasions. Bashfully hiding behind MacKenzie as he practices in this 1920 photo is a neighbor boy, Leon Baird, destined to become MacKenzie's step-son-in-law.

Butchering hogs was a big job whether on a small farm or a big ranch. The meat had to be processed properly. One man, who claimed to be an expert at curing pork, spoiled hundreds of carcasses for the Embar and Padlock ranches because his brine was not correct.

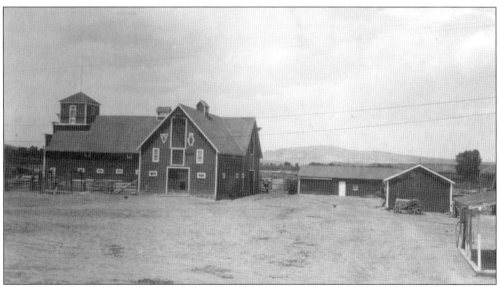

George Sliney, after serving all over the West in the Indian wars, chose the Owl Creek Valley for his family's home. After Sliney retired, his partner H.P. Rothwell sold their Padlock Ranch to Fred Klink of Denver and T.A. Snidow and Lee Simonsen of Billings. The latter lived at the ranch and went on a building spree that included a thousand-sheep shearing pen, quarters for 124 ranch hands, and this fine horse barn.

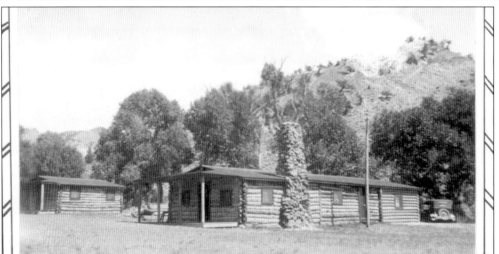

A lot of entertaining went on at actor Tim McCoy's dude ranch on the North Fork of Owl Creek. He put up picturesque buildings for the tourist trade, but was away too often to make a success of the business.

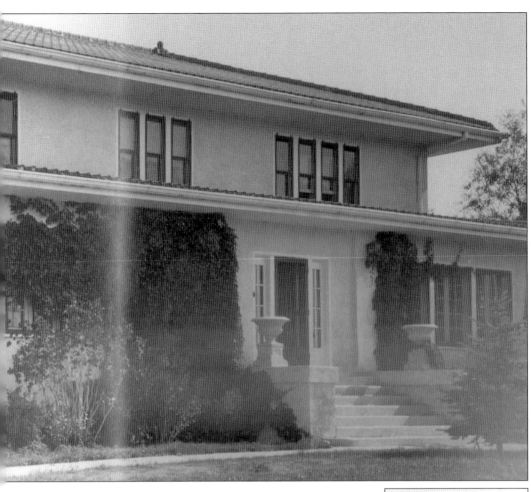

Simonsen's biggest building expense was this mansion, an "Italian villa in a sagebrush flat" as one Denver paper put it. Costs were reported at between $50,000 and $80,000. Pre-built stairs were bought in Oregon, broadloom carpets were custom-woven in England, and Oriental rugs were laid down. There was a large wine cellar in the basement. The Simonsens entertained extravagantly, and overspent. Gavin Richmond, whose parents were friends with the Simonsens, said that sheep "walked off the ranch" and equipment borrowed by neighbors wasn't returned. "Simonsen didn't care because he was a friend of everyone on the creek." The ranch went into receivership. The government bought it for the Arapaho Indians in a complicated deal involving compensatory funds paid the Shoshoni for sharing monies from the sale of the springs with the Arapaho.

Among those who duded up for McCoy's clients was Laurence Anthony, shown here in his "Wyoming" chaps. Anthony was also a working cowhand and an expert carpenter. The capriciousness of Wyoming's weather is apparent in this snowy photo taken in June of 1929.

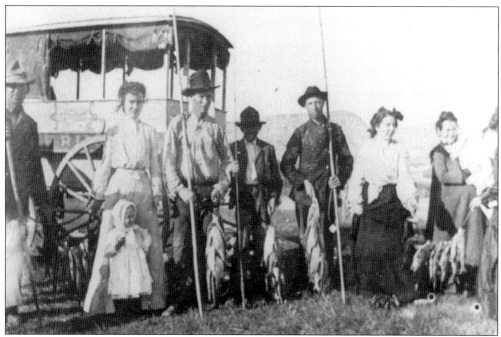

The Sliney, Holdrege, and Rankin families show off their great catch of fish c. 1900. Many county residents went to the Big Horn Mountains, Jackson Hole, and other locations, including Yellowstone Park, as tourists and fishermen.

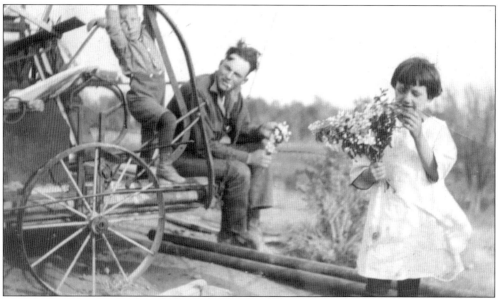

Simple pleasures, such as picking wild flowers, were appreciated too. Esther Buchanan admires her bouquet and shares a quiet moment with her little brother, Freddie, and an unidentified hired man. At age 13, Freddie died of injuries from a horse accident. Country children learned that both birth and death were natural, and to enjoy the flowers while they bloomed.

Three
TRANSPORTATION

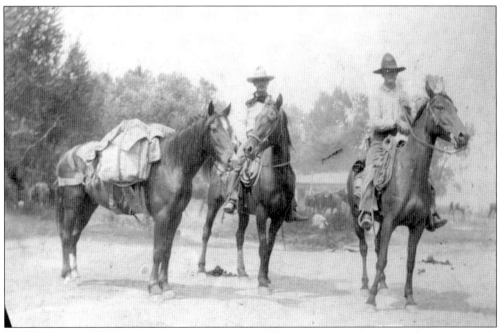

Will Price, son of Embar foreman Jacob Price, and Dick Teas, a cowhand and friend, are ready to pack into the high country from headquarters on Owl Creek. Packing was an art. Loads had to be secure enough to stay on over the steep trails. Sometimes a great packing job was demolished when a cantankerous horse decided to unload.

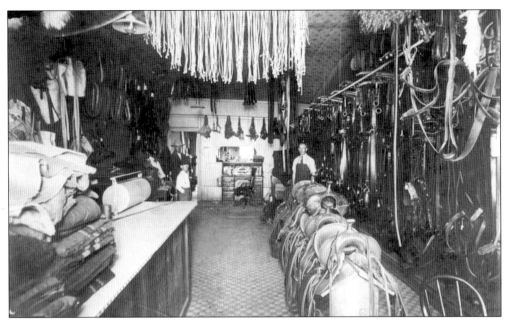

Thermopolis Saddlery was started by the Hank brothers, who were also horse ranchers. The original shop burned and they moved next door into the Stone Front Barn, which was on the site of today's post office. Warren A. Scovel, wearing the apron, bought the shop in 1913. He advertised "Made to Order Saddles a Specialty" and put out a catalogue. His saddles were favorites in Wyoming for many years.

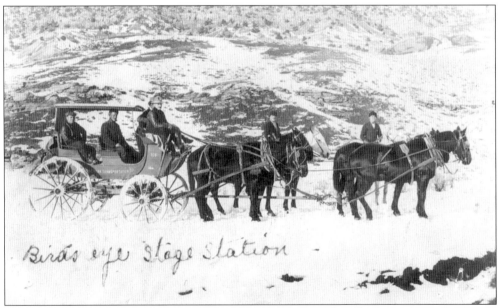

The Clark Transportation Company ran a stage-freight-mail line from Casper, Wyoming to Thermopolis. They charged $16 per passenger, with the trip taking up to 30 hours. The first route followed the Bridger Trail, down Kirby Creek. After the railroad reached Shoshoni the stage crossed Copper Mountain at Birdseye Pass and came down the treacherous Devil's Slide section. Sub-contractors were Thermopolis stable owners Pardee and Junkins.

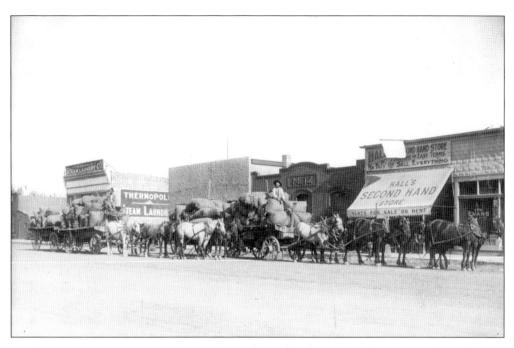

Ready to haul wool to the railroad, this six-horse freight team will return with supplies for businesses such as these between Fifth and Sixth Streets on Arapahoe. Broadway, Thermopolis' main street, had been laid out wide enough that a 16-animal team could turn around easily in it anywhere. After fighting roads for a month from Casper, in the spring of 1898, "a quartette of boss freighters . . . pulled into town in circus style." In the second photo, A.O. Metz, photographer, trademark derby in hand, had a bystander snap the photo so he could pose with these 10-horse outfits loaded with lumber in front of the Stone Front Barn and Livery.

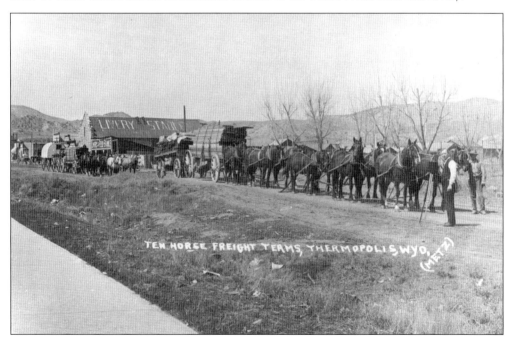

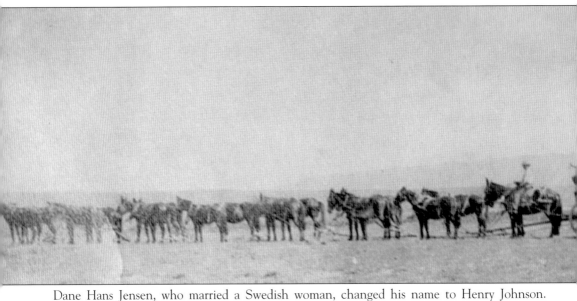

Dane Hans Jensen, who married a Swedish woman, changed his name to Henry Johnson. "Sixteen-Mule Team" Johnson had the only all-mule team in the county. He hauled three freight wagons, plus one in which to live, a "cooster". During the 1906 opening of additional reservation lands for homesteading, freighters could not keep up despite the shorter hauling

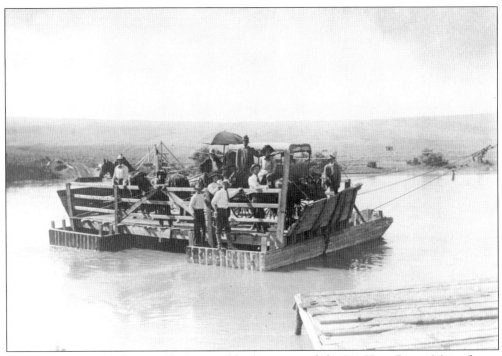

Ferries were essential for travel before steel bridges spanned the Big Horn River. Major ferries in operation in the county, besides those at the springs, were at the old town of Thermopolis and this one at the mouth of Buffalo Creek just downstream from the mouth of Wind River Canyon. Shown here in 1900, it was kept busy with stages and private outfits coming over Birdseye Pass. (Courtesy Wyoming State Archives.)

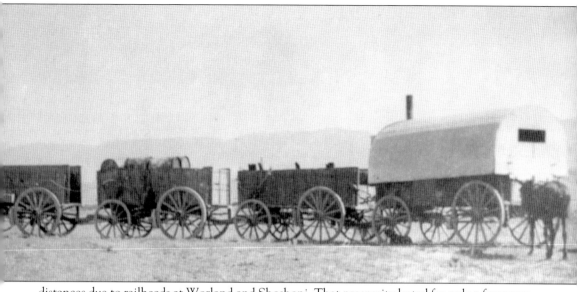

distances due to railheads at Worland and Shoshoni. That prosperity lasted for only a few years. Many freighters left after the railroads came, but Johnson and Emereth Boots, who had brought cattle up the Texas Trail, stayed, becoming ranch neighbors. In 1939 the families merged when Vince, Boots' son, and Minnie, Johnson's daughter, were married.

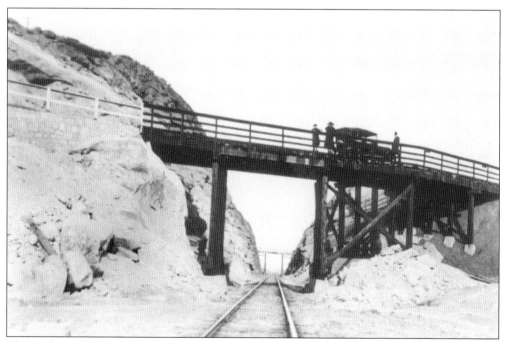

The road north out of Thermopolis was dangerous due to high hills with a rimrock running to the river. The railroad blasted Cover's Cut (named for a nearby ranch family) through the rim. Cars had to cross the tracks twice on blind curves. Several bad accidents occurred. The solution wasn't much better. This pair of bridges had dangerous, steep approaches. Not until 1936 was the current roadbed laid. (Courtesy of Ken Martin and Dorothy Milek.)

Kirby was the county's railroad town with a roundhouse, engine barn, section houses, depot, livestock loading facilities, and wool warehouse. Upon the railroad's arrival, John Nelson, who had homesteaded the site, built a hotel. Other businesses followed, but all were destroyed by fire in 1909. Clockwise from the left in this 1919 photo are a blacksmith shop, a barn, and the white

jail at left rear. The white back walls of the post office and the rebuilt Kirby Hotel are barely visible at the center right edge of the photo. The Kirby Depot is the dominant building. Between the depot and back of the post office building are the running gears of many wagons, symbols of the freighters who had to call it quits.

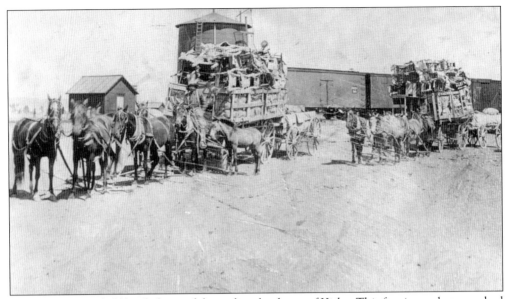

Ash and J.B. Mayfield hauled one of the earliest loads out of Kirby. This furniture photographed in 1907 was bound for the new Emery Hotel in Thermopolis. At first railroads, horses, and autos didn't mix. Horses bolted when trains "steamed up." The Kirby-Thermopolis stage was upset and its passengers thrown "promiscuously" into the sagebrush when the driver swerved to miss an "infernal" car.

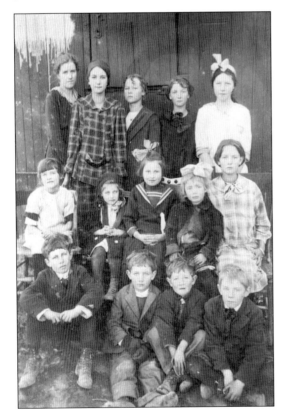

This 1914–1915 photo of Kirby students is taken alongside their "poorly equipped" boxcar school. Pictured here are, left to right: (bottom row) Clifton Wight, Jack Kelly, Wilbert Kelly, and Eldon Odiorne; (middle row) unidentified (reported to have died of the flu), Holly Wight, Lavonne Perry, Nellie Kelly, and Ruby Kelly; (top row) teacher Bertha Ryan, Margaret Kelly, Maggie Barham, Pearl Kelly, and Elva Russell. (Courtesy of Ruby Kelly King and Dorothy Milek.)

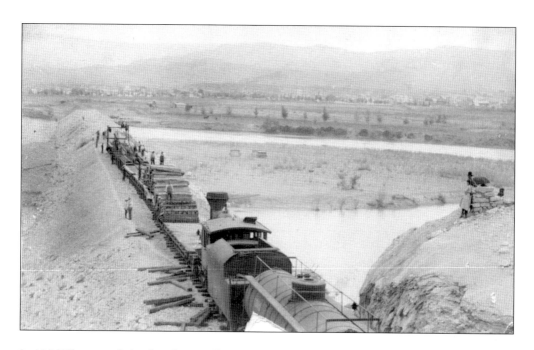

In 1906 Thermopolis' railroad was still in limbo because of the formidable Wind River Canyon to the south. If the Burlington decided not to tackle it and went up Kirby Creek instead, Thermopolis would be bypassed. That was unthinkable, so the town fathers bought the right-of-way through town and gave it to the railroad. In June 1910 tracks were laid into town. The work train pictured here is in the cut that ruined business at Pleasant View Sanitarium, out of sight to the right. While the railroad's advent hurt some businesses, others such as Fell's dray service, shown in this photo at the depot, prospered.

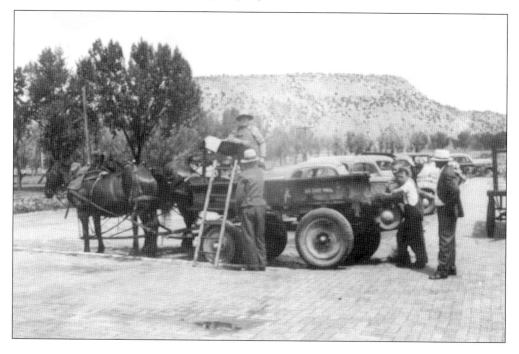

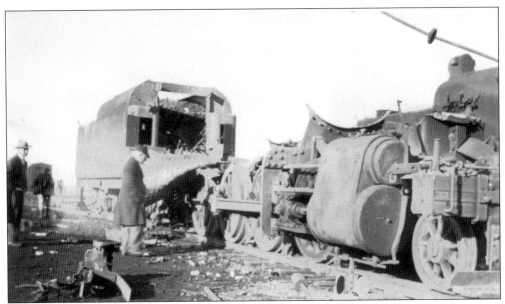

Railroad accidents are fairly common in the county, especially in Wind River Canyon, due to landslides. Wrecks were also caused by human error. Failure to put enough water in the boiler of an engine at Kirby resulted in an explosion that killed the fireman outright. The engineer was dead on arrival at the Gebo hospital, and the brakeman may also have been killed, according to the donors of the photo to the Hot Springs County Museum, Andrew and Harry Johnson.

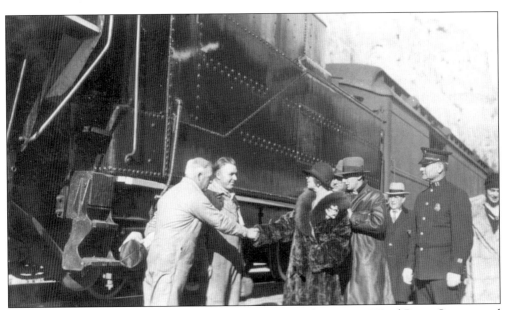

The Queen of Romania and her entourage stopped to see the view in Wind River Canyon and did some handshaking. This 1926 photo was probably taken at Dornick way station. The Burlington was sidetracking passenger trains there for 10 minutes of sightseeing.

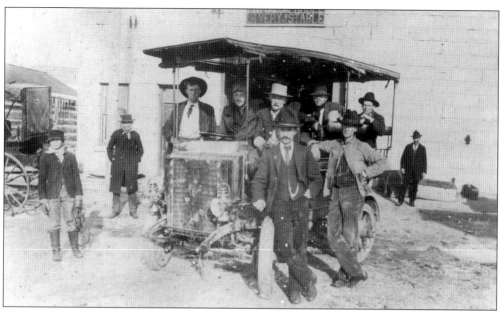

Flivver fever hit Thermopolis in 1905 when Ralph Adams jockeyed the first car over Stagner Mountain for its eastern owners. With only two cylinders, the car didn't have much power, so it was pulled most of the way from the railhead at Rawlins. Photographed with the car are, left to right: (?) Smith, Grandpa Irwin, Walt Gundecker, driver (?) Nauttuly, George Pardee, S.H. Plummer, Vern Kellogg, Charles Ross, Jimmy Hines, and Sam Griffith.

CITY TAXI AND BUS LINE

Phone 68 Phone 68

GO ANYWHERE AT ANY TIME

Stand at Mission, Next Door to Postoffice

M. C. PETERS, Proprietor Thermopolis, Wyoming

Ted Hank started a taxi service to the Reserve with the car. The owners had skipped out owing $600 on it. Hank quickly paid off the loan by driving from daylight until long after dark, often making $50 a day. At train time cars, hacks, and buses, such as these in the photo, were waiting at the depot, their drivers vying for passengers.

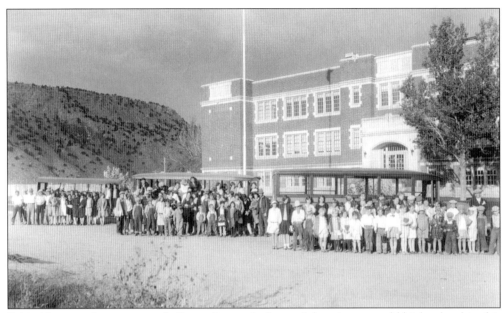

School buses and youngsters of all ages line up in front of the nine-year-old high school in this 1930 photo. Prior to buses being run, rural students often boarded in town. Girls lived on the top floor of the high school and boys at Julia Holdrege's house across the street.

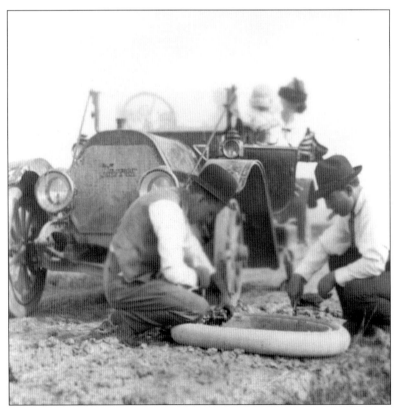

Flat tires, such as the one in this photo, broken arms from crank kick-backs, miring in mud, and un-bridged river crossings were among the hazards of the new transportation mode. It took a good cigar and lots of concentration to change a tire while the ladies looked on. Livery stables became "auto liverys." The smell of oats, hay, and manure were replaced by those of exhaust and gasoline fumes.

Such problems as flat tires and the need for easy access to gas and oil led to the opening of the first service station in Thermopolis. It was located on the south side of Broadway just west of the railroad tracks. Note the Cover (Broadway) Hotel and Lunch Counter across the street. Frank Davis is standing at the left in this 1915 photo.

Joe Sneider was the first bulk gas distributor in town. Here he is parked at the southeast corner of Broadway and Sixth beside the Sideboard Bar. On a similar cold winter day at a spot above the Big Spring, now called Sneider's Point, Sneider spied what he thought was smoke from an Indian encampment and sneaked away. It was, of course, steam from the springs.

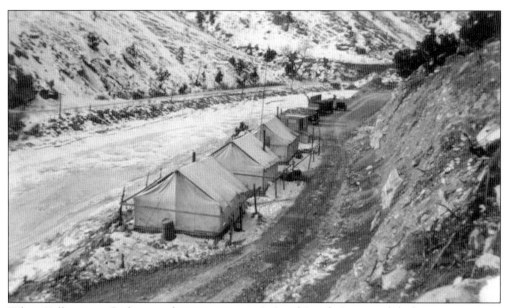

When Yellowstone Park opened to autos in 1915, Good Roads Booster clubs began promoting a highway from Denver to Yellowstone. The road over Birdseye Pass was improved and was among those marked with stones painted yellow. State officials and Good Roads activists supported a canyon highway, begun in 1922. Campsites for the crews were carved out of the canyon walls.

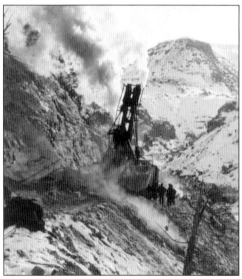

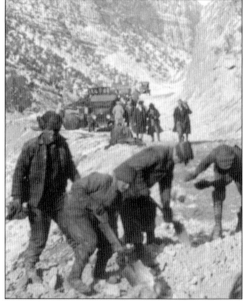

To build the canyon road an estimated 186,000 cubic yards of material, much of it granite, had to be moved. Earth slides, difficulty in moving supplies, weather, deaths and injuries, and flooding from a dam at the head of the canyon slowed progress. In January 1924 the last official mechanized shovel-full of earth was dumped.

Laborers had to clear rubble ahead of the first official caravan as the cars slogged through the canyon from Thermopolis to the south end. There an elk dinner was served by the contractors, and John D. Woodruff told of first seeing the canyon in 1884.

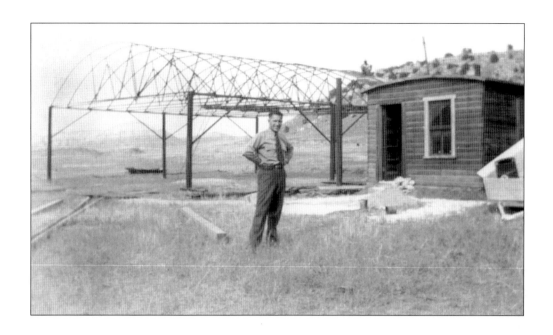

While workers were struggling to build railroads and highways through the canyon, the newest form of transportation had appeared in the skies above Thermopolis. Gertrude Lyon, a quiet-living candy maker, volunteered for the first parachute jump over the town in 1920. The first commercial flight was made by Ted Hurlburt and Bob Copsey, who flew their Eagle Rock plane in from Denver c. 1927. Wertz Hancock, whose commercial partner was Slick O'Neill, is pictured standing in front of their office and hanger. Flying accidents took a high toll of county pilots, including O'Neill. Gebo and the oilfields had landing strips in the sage. This biplane is being inspected by a group of miners from Gebo.

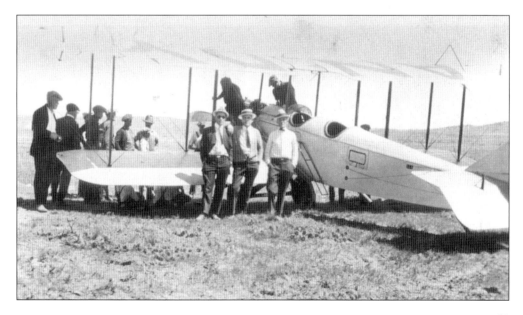

The official opening of the canyon highway was held in July of 1924 and filmed by Fox Pictures. Cars and buses gathered at the Wedding of the Waters (where the Wind River becomes the Big Horn River at the mouth of the canyon). Bottled mineral water broken over a nearby boulder christened the road. The grand climax was a parade through the canyon to place a bronze plaque on the site of Boysen Dam, destroyed after it had flooded the railroad. Across the river beside the passenger train was the future of the railroad: freight cars and cattle-loading yards. With automobiles now able to travel the canyon, through passenger trains would become a thing of the past. Overhead was another symbol of the future. Native son George Rice of Kelly Field, Texas, did a flyby. And somewhere on the edge of the canyon a horseman sat remembering the days when travelers went through the mountains, not over them. Barriers to Hot Springs County were finally gone. (Courtesy of Smoky Monroe and Dorothy Milek)

Four
LAW AND OUTLAW

Even before the days of the "wild west" were over, the Western outlaw had become a figure of popular legend. In a mock hold-up staged for the camera in 1908, southwest of Thermopolis, the gentlemen and ladies took turns at playing the outlaws. Like many other historic photographs in the Hot Springs County Museum collection, this picture was damaged in the museum fire of 1967.

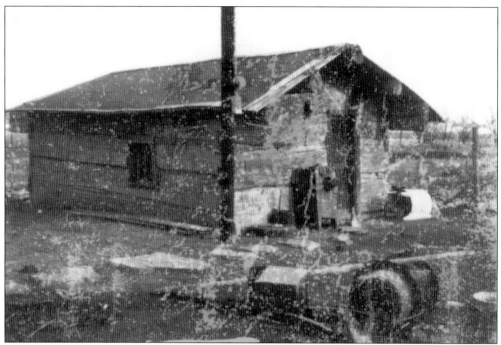

The hamlet of Andersonville, which flourished briefly in the 1890s about six miles north of modern Thermopolis, was a Mecca for area outlaws. Celebrated desperados such as Butch Cassidy gravitated to Andersonville's saloon from their hideouts around the Hole in the Wall country in central Wyoming. Today no buildings remain on the site, but when this picture was taken in the 1950s, this log cabin still stood as a reminder of Andersonville's adventurous past.

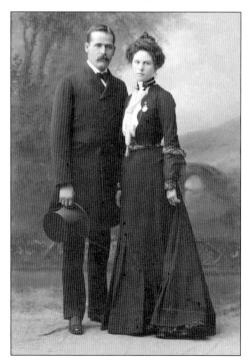

Among the famous characters who frequented the Thermopolis area was Harry Longabaugh, better known as the Sundance Kid. This print of the well-known photograph of Sundance and his mysterious girlfriend Etta Place belonged to Minnie Brown, whose husband Mike was a suspected rustler and a friend of Butch and Sundance. On the back of the photograph Minnie wrote: "This gentleman was one of the real gentlemen who know how to get the money and not cripple or kill."

Mike Brown posed for this portrait in 1891 in Omaha, on his first trip back east shipping cattle. Mike, a friend of Butch Cassidy and his gang, was suspected of hiding the outlaws after the Wilcox train robbery in 1899. When Mike was murdered in 1908, his second wife Minnie claimed she had shot him to stop him from beating her. However, some suggested Minnie had taken the blame to protect the real killer.

Maude Brown's life ended in almost as dramatic a way as that of her husband Mike. She was dancing at the Christmas Eve dance in Thermopolis in 1900, when she suddenly collapsed and died. Maude's funeral was one of the best attended in early Thermopolis, and members of the local Masonic lodge carried her coffin.

Mike Brown's second wife Minnie (left) was a notorious character in her own right. Rumored to have had a "questionable" past, her husband's sensational death didn't improve Minnie's standing with the respectable women of Thermopolis. However, her sense of humor saw her through many tough situations. Here she poses with her friend Fannie Berg in one of a series of humorous photographs taken on Easter Sunday around 1915.

Ed Anderson was the black sheep brother of Charles Anderson, one of the first County Commissioners of Hot Springs County. An anonymous note on the back of this photo reads: "This will introduce to you Mr. Ed Anderson—just between you and me he borrowed this makeup when the owners were not in their cabins. A picture taken when came in town. Poor Ed had the urge."

Tom O'Day, described in the *Billings Gazette* as "a merry, light-hearted Irish boy," rode with Butch Cassidy's gang and for a while had another outlaw gang under his command. Jailed in 1904 for horse stealing, he apparently went straight after his release. Tom is shown here with his wife Winnie and riding his horse Croppy, which according to the note on the photograph "could run a quarter [mile] in nothing."

Kize Eads, photographed with his wife Clara, was a skilled bronc rider and a suspected rustler. While competing in a bronc riding contest at the 1905 Fourth of July celebration in Thermopolis, Kize got word that his friend Bob McCoy had been murdered by men who accused him of cattle rustling. Knowing he was next on the killers' list, Kize fled Thermopolis. He later worked as a government horse buyer in New Mexico.

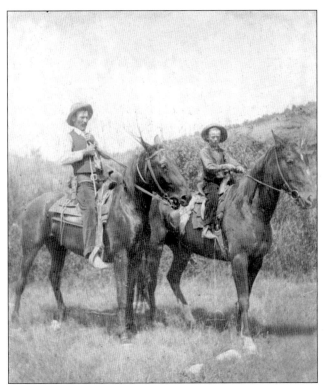

The photograph to the left shows Kize Eads and his son Wilton, about two years before Kize's hasty departure from the Thermopolis scene. The outlaw family album continues below with a picture of Kize's father Charles "Dad" Eads, who was also in the rustling business and spent time in the Wyoming State Penitentiary. His outlaw days seem to have been far in the past when Dad Eads posed for this picture with his great-grandchildren, Charles Monroe Link and Marguerite Bell Link in 1924.

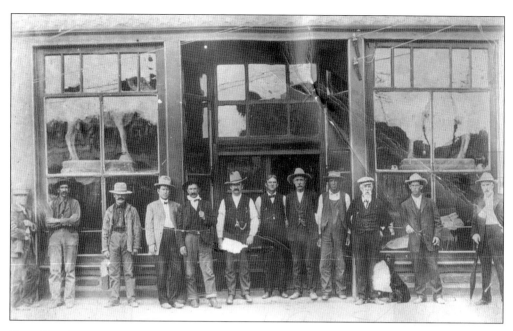

Tom Skinner, a Texas cowboy turned saloonkeeper, named his Hole in the Wall Saloon after Butch Cassidy's gang, who were among his best customers. Tom operated saloons in both Old Town and the modern location of Thermopolis, and became one of the town's most admired civic leaders. The picture above, taken outside the Hole in the Wall Saloon around 1908, shows an unidentified man, "Mexican Pete," Frank Reed, Charlie Clayton, Savus Adolphus Plummer, Tom Skinner, Hosea Hantz, Hank Cover, Charlie Chatman, Mike Maley, and two unidentified men. The picture below shows Skinner's cherrywood bar, which he had imported from Ireland. It arrived in Thermopolis in freight wagons, since the railway was not yet built. Holding up the bar are unidentified, Shorty Gordon, two unidentified, Silvanus Plummer (possibly the same man as Savus Adolphus, above), bartender Jim Lucas, Marion Cover, and Floyd Slane.

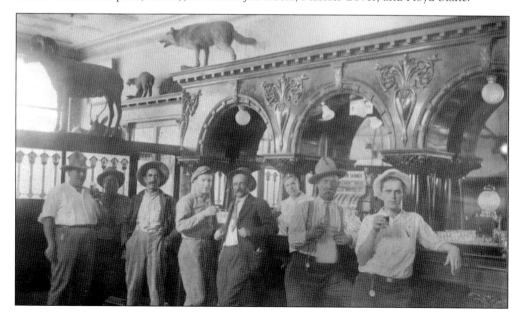

Tom Skinner's chief rival in the early Thermopolis saloon business was Jack Hollywood (left figure in photo to the left), whose establishment stood right next door to Skinner's Hole in the Wall Saloon. Jack's family emigrated from Scotland when he was three years old. In the 1890s and early 1900s he was famed in Thermopolis as a gambler, entrepreneur, and gunman. Accused of at least three murders, he was only convicted of one manslaughter, which he contested by arguing that the deceased had been recovering nicely from his gunshot wound, and had died of pneumonia. The man at the right in the photograph to the left is tentatively identified as Jack Palmer, who served as a deputy sheriff in the 1920s. Below is pictured the interior of Hollywood's Saloon, in 1901.

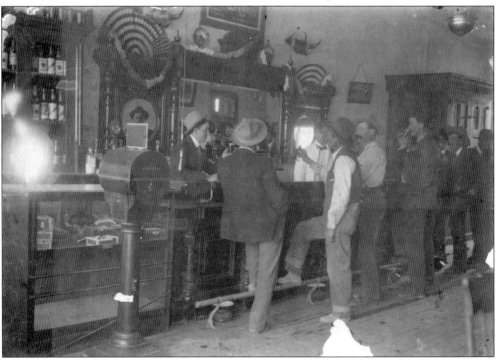

Just down Arapahoe Street from Skinner's and Hollywood's saloons, the unimposing wooden building behind the trees served for decades as the Hot Springs County Courthouse. The small stone building on the left was used as a soup kitchen during the Depression years.

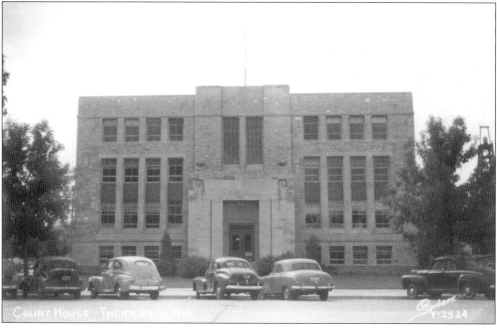

Hot Springs County gained an impressive new courthouse in 1938, when the courthouse that stands today was constructed with funding from the Works Progress Administration and the Public Works Administration. During the campaign for a new courthouse, the Thermopolis newspaper ran a story about a stranger to town who drove twice around the block without recognizing the "long, low building without much paint" as the courthouse.

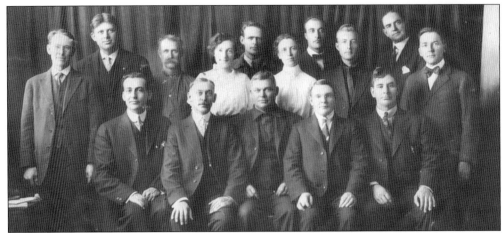

Hot Springs County was created in 1911 out of portions of Fremont and Big Horn counties. The first Hot Springs County officers were (seated): attorney Victor T. Johnson; commissioners Nate Wilson, Charlie Anderson, and Charles Barnard; sheriff Scott Hazen; (standing) assessor Robert Price; clerk Hosea Hantz; road superintendent George Short Jr.; deputy clerk Dale Pickett; deputy sheriff Harry Holdredge; superintendent of schools Nellie Wales; coroner Lew Gay; deputy surveyor Frank May; health officer Robert Hale; and treasurer M.E. Congdon.

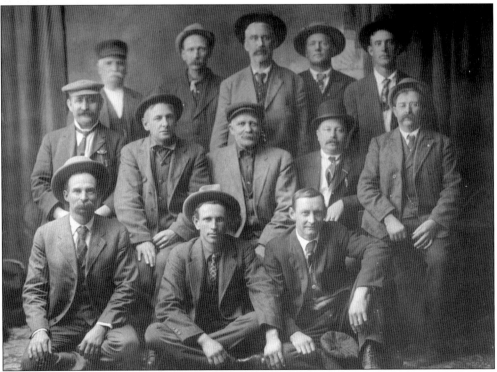

A local man named Lenwood Smith was tried for the desertion of his family in 1914. The jury was a selection of ranchers, farmers, hotel and bathhouse owners, and at least one bartender. Pictured here are: (front row) Charles McCumber, H.A. Robinson, and Al Rohr; (middle row) "Happy Jack" Davies, Harry Vail, George M. Sliney, Sam Peterson, and C. Fell; (back row) Ira Beals, Allen Hicks, M.D. Gregg, George David, and John Dockery.

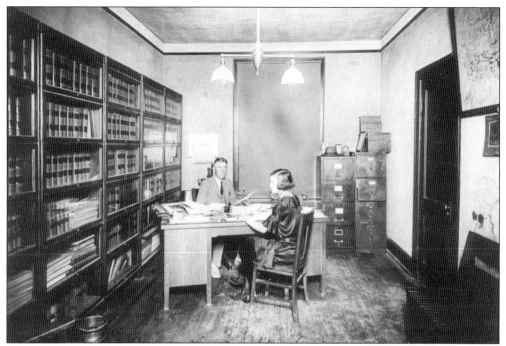

In this picture of the county attorney's office in 1922, Fred Wyckoff is the attorney and Bertha Burnap the secretary.

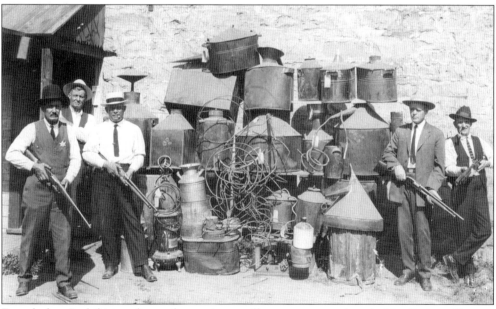

Even before Prohibition, liquor from private stills was commonplace in Hot Springs County, where the terrain provided good hideouts for moonshiners. Many county residents were immigrants from cultures with long traditions of home brewing and distilling. Whatever their backgrounds, for many in the region Prohibition was less a law than it was a declaration of war. Among the Prohibition era lawmen posing with these confiscated stills are Deputy Sheriff Lee Mathers, Sheriff Harry Holdredge, and Deputy Jack Palmer.

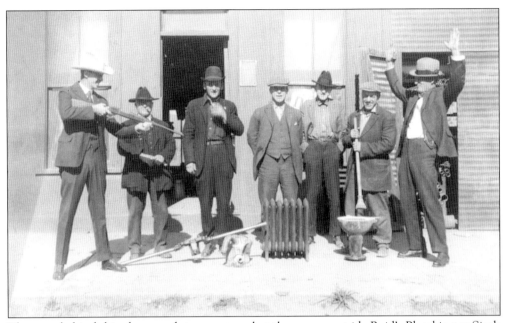

The story behind this photograph is a mystery, but these men outside Reid's Plumbing at Sixth and Arapahoe may be spoofing a scene of lawmen, bootleggers, and captured stills, like the one on the previous page. Those identified are Earl Baker, James Reid, Joe Bush, and a Mr. Godsey.

Hot Spring's County's "Prohibition War" brought tragedy to the family of Ted Price, shown here, a deputy sheriff killed in a September 1921 shootout with bootleggers. Prohibition became a catalyst for violence and corruption in rural Wyoming, just as in urban centers like Chicago. Among the many other casualties was Scott Hazen, Hot Spring's County's first sheriff, who resigned in 1925 amid allegations that he was involved in bootlegging.

Five
THE MINING TOWNS

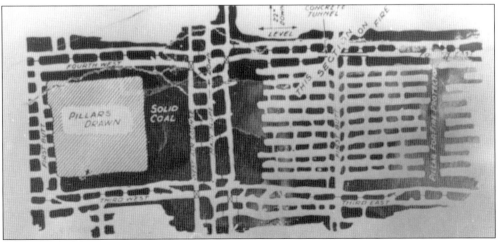

This working plan from a coal industry publication shows a section of Gebo Mine #1. Gebo and Crosby were towns created by coal mining, and the decline of the industry caused both of them to fade out of existence.

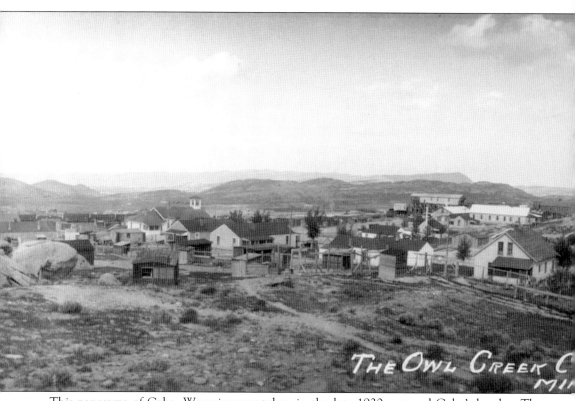

This panorama of Gebo, Wyoming was taken in the late 1920s, around Gebo's heyday. The Owl Creek Coal Company town flourished from around 1906 to 1938, and had a brief

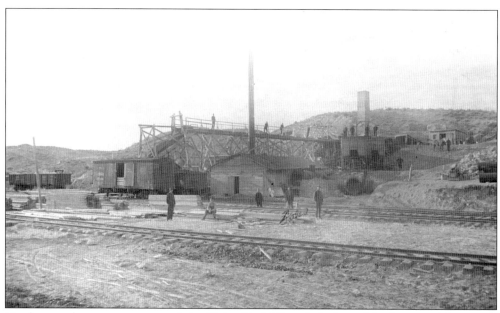

Crosby was the company town of the Kirby Coal Mine. It had roughly the same life span as Gebo, beginning a year later in 1907 and staying active until around 1933. A flood and an underground fire in the late 1920s marked the beginning of the end for Crosby. These

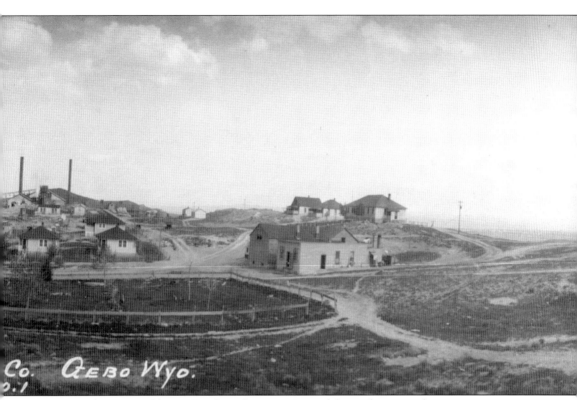

resurgence during World War II, when the nation's need for coal increased.

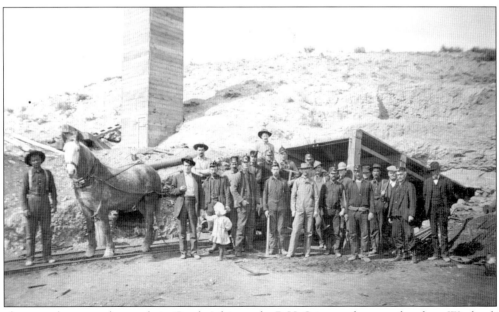

photographs were taken early in Crosby's history by R.H. Stine, a photographer from Worland, the county seat of Washakie County, and Hot Springs County's neighbor to the north. One of the men in the picture to the left is identified on the photograph as "Father."

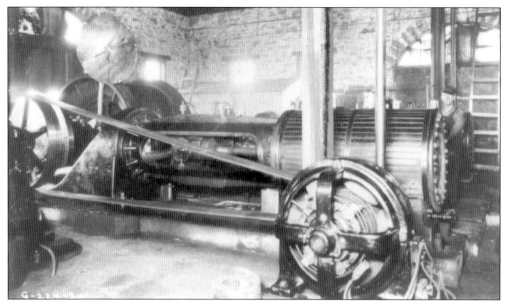

This photograph shows the hoist that powered the coal cars up and down the mineshaft in Gebo Mine #1. The hoist and other machinery in the mine's engine house were powered by electricity. Coal cars went into the shaft on rails and worked on a setup similar to that of an electric streetcar line.

Owl Creek Coal Company blacksmiths Eli Talovich and Ray Dickey pose outside their blacksmith shop in Gebo, in a photograph taken in the late 1920s. Talovich was one of the many Eastern European immigrants who worked in Wyoming's mining towns. Their large numbers prompted the joke that one wasn't a real Gebo person unless one's name ended in "vich." (Photograph courtesy of the American Heritage Center, University of Wyoming.)

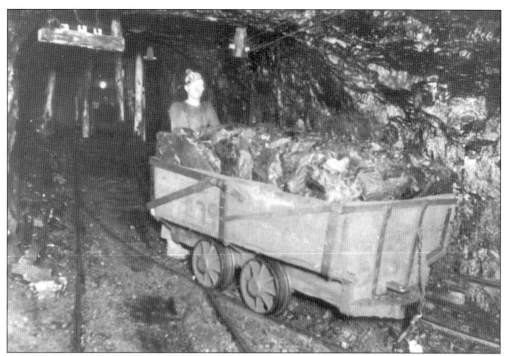

An unidentified miner stands with his loaded coal car in Gebo Mine #1. The timbers that reinforced the mineshaft are visible behind him.

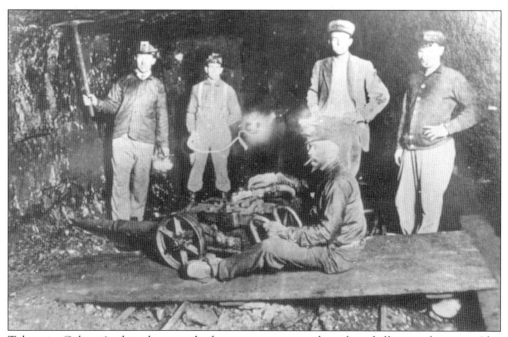

Taken in Gebo #1, this photograph shows miners at work with a drill or coal cutter. Also noticeable are the pick in the hand of the man on the left, and the lights in the center of the picture and on the hard hat of the man sitting in the foreground. The seated man's cigarette adds a relaxed, casual air to the scene.

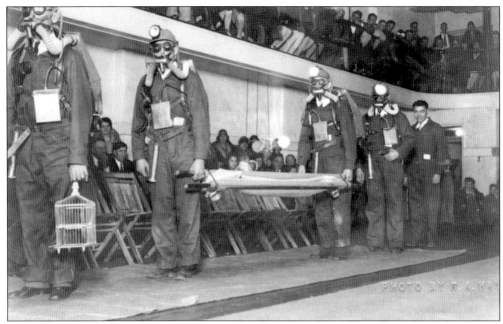

The Gebo Mine Safety team won many awards across the state of Wyoming. Here the team is shown during a safety techniques demonstration at the high school in Thermopolis. The team's equipment included both high tech and low tech items, from oxygen masks to a canary in a cage. The last man on the right is Tony Pisto, who worked for many years at the Smokehouse cigar store and pool hall in Thermopolis.

The Gebo Church was used by all denominations, with a part-time pastor usually being provided by the First Baptist Church in Thermopolis.

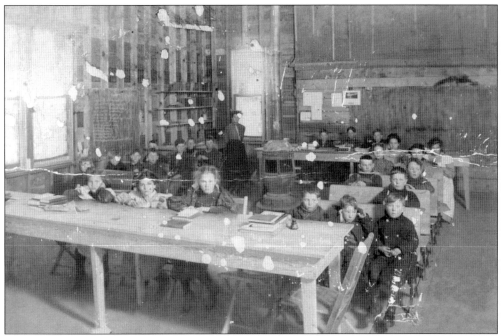

These children and their teacher were photographed in the one-room schoolhouse in Crosby. Notable details include the ink bottle on the front table and the stove at the center of the room, which provided heat for the school. Typically, the teacher would arrive early to light the stove before students arrived, and one of the criteria by which children judged their teachers was whether the teacher could get a good fire going in the stove.

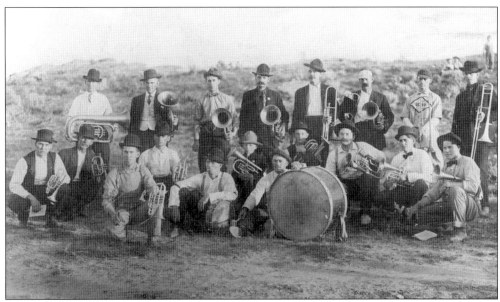

Although it is a ghost town today, in its heyday Gebo had plenty of cultural activities. Here, the Gebo Miners Band poses for a group photo in the early 1920s. Band director Bob Rae is kneeling third from left, with his trumpet and his conductor's baton. Second from right, in the back, one of the musicians is wearing his Gebo baseball team uniform.

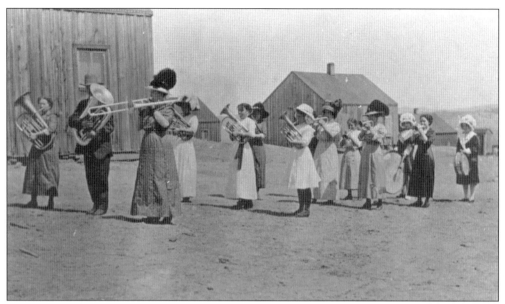

The Gebo Ladies' Band was photographed marching through town in the mid-1910s. Most of the band members wear hats, as fashion and propriety dictated that both ladies and gentlemen should whenever they were out of doors. A few, however, have adopted a more casual look and are bare-headed. Other photographs taken on the same occasion show that the large drum near the back was borrowed from the Gebo Miner's Band.

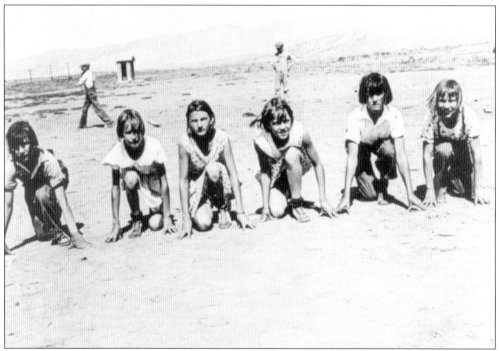

Around 20 years later, a group of Crosby schoolgirls are photographed about to start a race. Identified are Agnes Panelus, Rosa Plachey, Janet McClusky, Rose Kitzerow, and Elsie Toth. The outhouse visible in the background was a typical sight, since Crosby was without running water.

Labor unions played an enormous role in the lives of Gebo and Crosby's citizens, and Labor Day was one of the biggest events of the year. This advertisement for Gebo's 1923 Labor Day celebration was printed by the *Billings Gazette* in Montana. The picture of a parade of Gebo and Crosby union workers probably shows either the annual Labor Day celebration in Gebo or the April 1 commemoration of the eight-hour workday, held annually in Crosby. The banner of Crosby Local Union Number 2700 is visible in the crowd, and the sign on the truck at the right urges, "Fill Your Bins With Gebo Coal". (Poster courtesy of the University of Wyoming.)

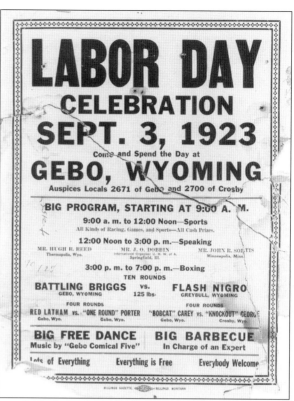

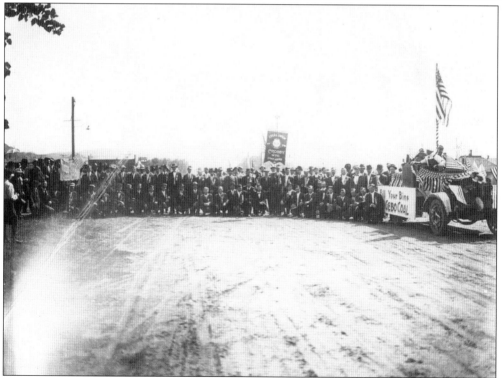

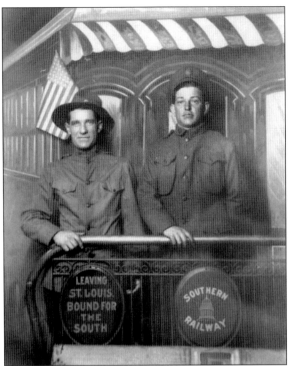

Crosby men Frank "Frenchie" Cabre and M.L. Garette posed for this comic postcard photo in their uniforms when they left home to serve in World War I.

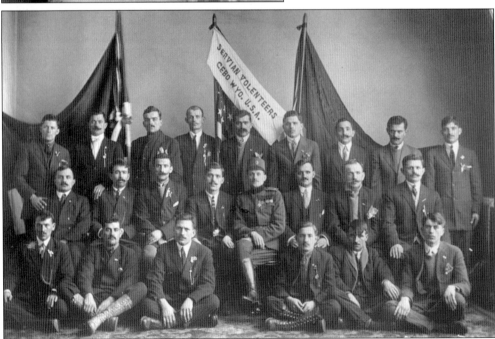

World War I had a deep impact on Gebo, Wyoming. Twenty-one Gebo men of Serbian ancestry left together for the War in response to a recruiting visit by Sergeant Major George Petrovich of the Serbian War Mission. In all, around 50 Serbians from Gebo answered the call to arms. An article in the Thermopolis newspaper wrote of "the bond of blood brotherhood between our own brave boys in service and the Serbs who went out from among us."

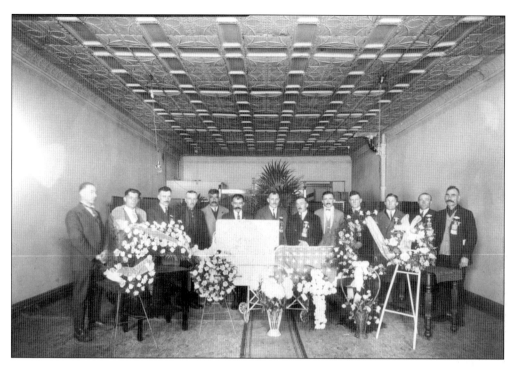

These two photographs show the funeral and burial of a Serbo-Croatian coal miner from Gebo. Although Gebo did have a cemetery, these services are taking place in Thermopolis, at the Eastman Mortuary and the Monument Hill Cemetery. The banner of Gebo Local Union Number 2671 is visible, proudly displaying the union slogan of "Eight Hours."

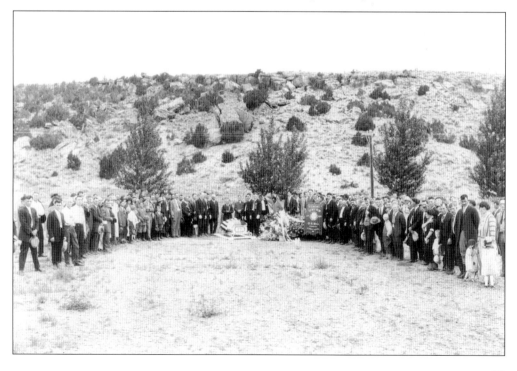

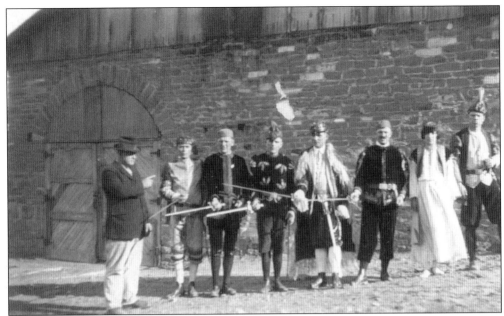

Gebo had a reminder of the Old Country in a Montenegrin-Serbian play presented in the late 1920s, using traditional costumes and performed in Serbo-Croatian. The actors and an uncostumed man, possibly the play's director, are apparently posed in front of the Gebo Mine engine house.

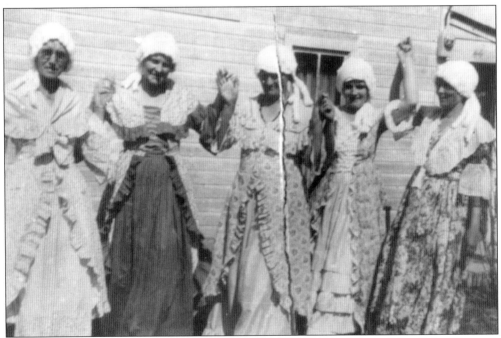

Illustrating another aspect of Gebo's multi-cultural heritage, the ladies of the Gebo Women's Benefit Association pose in Revolutionary War era costumes for an unidentified event around 1930. Pictured are Dot Latham, Suzie Trusheim, Mrs. Congdon, Pearl Fletcher, and "Mother" Morton.

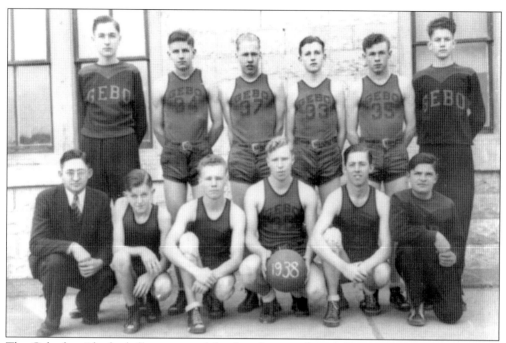

The Gebo boys' basketball team posed for this photograph in February 1938. In the front row are Mr. Speich (coach), Bill Burnell, Bill Maxwell, Arthur Cunningham (captain), Lloyd Hull, and George Talovich. In the back row are Bill Radulovich, John Trusheim, Eino Halone, Jack Burnell, Linolo Ponterolla, and Robert Pisto.

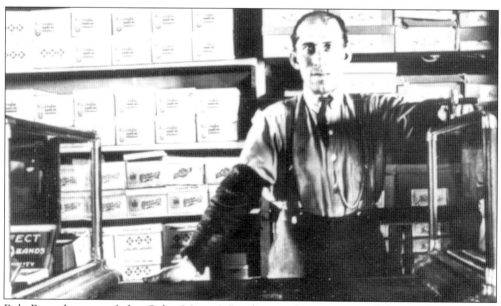

Bob Rae, director of the Gebo Miners' Band, was also manager of the Owl Creek Coal Company General Store, where this photograph was taken in 1914. He created the Gebo High School's music program, volunteering as an instructor and convincing the local union to pay for purchasing the instruments, which the school couldn't afford. In later years Rae owned and operated Gebo's pool hall.

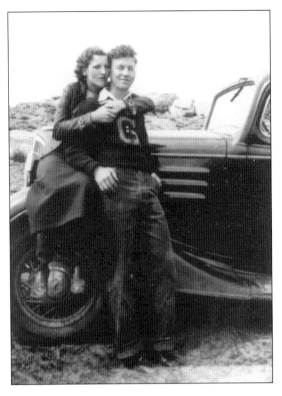

This couple, looking like the archetypal high school sweethearts, is made up of Ina Cunningham and Jim Rae, Gebo High School students in the 1930s. Jim and Ina were part of the end of an era: Gebo High closed its doors for the last time when the main Gebo mines closed in 1938, although the grade school continued for another 18 years.

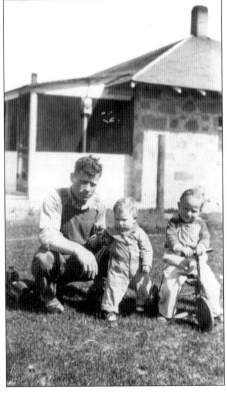

Milovan Jovanovich was photographed in the 1920s with his sons "Bunky" and Richard. The father and sons are outside their house on Gebo's "Rock Row," a street of matching stone cottages built by the Owl Creek Coal Company. The Jovanovich family, like so many other immigrants to the U.S., later changed their name, shortening it to Janich.

This charming studio portrait shows Milutin Shepanovich and his two children, photographed when Gebo was still as prosperous as the family's stylish clothing suggests. The little boy is the perfect image of his father, even down to the miniature watch chain.

Shown here are another family from Gebo's glory days, Zlatana Roganovich and her daughter Mary. Zlatana operated a boarding house in Gebo.

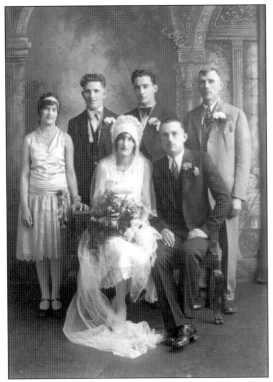

Looking hopefully into the future and dressed in the height of 1920s fashion, the Drashkovich wedding party posed for a commemorative photograph. A very different Gebo group had their picture taken in 1944, sitting in front of the last load of coal from Gebo Mine #1. The mine had been unsealed and reactivated during World War II by Dave and Bud King. Seated in front are Bud King and nephew John King. In the back row are Joe King (brother of Dave and Bud), two unidentified men, and Dave King. With the mines closed, Gebo's people drifted away, the buildings were gradually sold and moved to neighboring towns, and by the end of the 20th century only a few ruins remained.

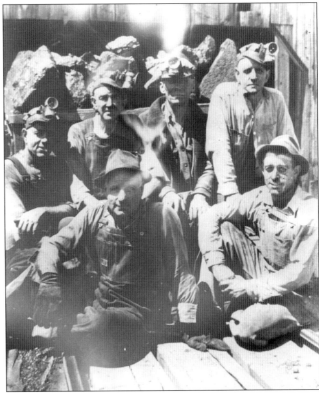

Six
THE OIL CAMPS

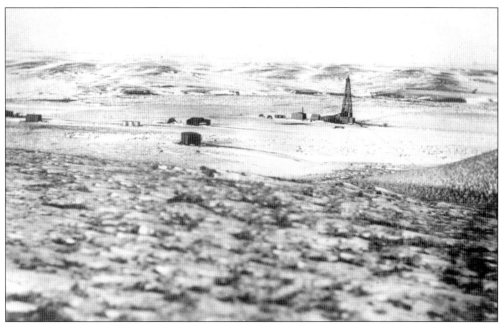

The expanse and frequent loneliness of Wyoming's "wide open spaces" is dramatically illustrated in this postcard of the Grass Creek oilfield, taken early in the oilfield's history. The rig and a scattering of buildings stand out starkly against a sea of snow and sagebrush.

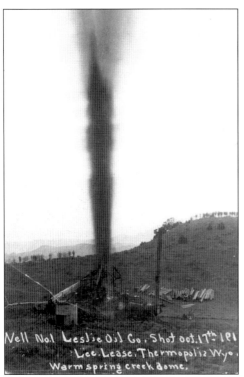

This postcard shows a "gusher" at Warm Springs east of Thermopolis, in a photograph taken as the first Warm Springs well came into production in 1917. A note on the back of the postcard reads "there is eight wells there now." Today, gushers are seen only when equipment failure or misjudgment allows gas pressure to build up enough to blow the oil from the ground. The dramatic, towering columns of oil are a thing of the past.

Thermopolis is at the bottom center of this map of area oilfields, date unknown, which shows the large concentration of fields that sprang up in and around Hot Springs County. Most of the fields shown here are still producing, but the demographics of the industry have changed. Due to increased mechanization and greater ease of travel, oilfields have fewer employees. The remaining workers now commute from Thermopolis and other area centers, rather than living at the oil camps.

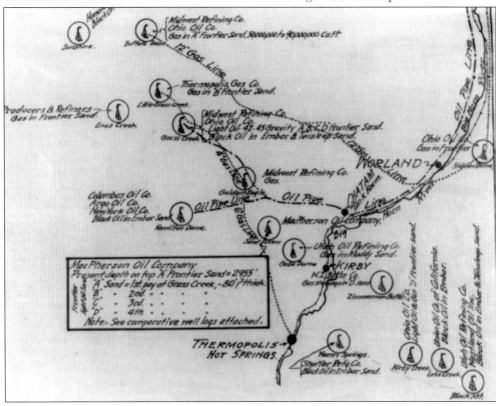

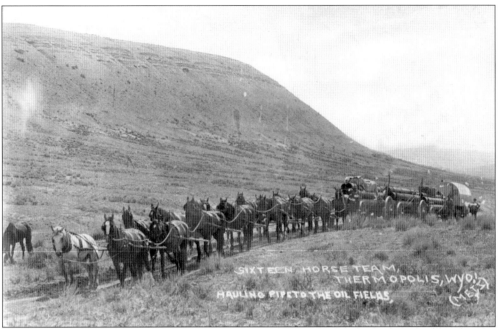

Today it may look strange to see the seemingly modern oil industry combined with images of the past, like horse-drawn freight wagons, as in this Metz Studio photo of a 16-horse team hauling pipe to an oilfield. But Hot Springs County's fields were a long way from the railroad, and trucks to haul heavy loads had not yet appeared in the area. In 1904 there were only 700 trucks in the entire U.S.

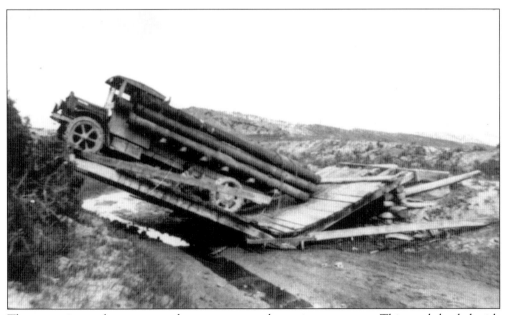

There are times when progress does not seem to be an improvement. This truck loaded with pipe has proved too much for the bridge, where the 16-horse team might have come through unscathed. Unfortunately, no photographs seem to have survived of the process of getting the truck off the bridge.

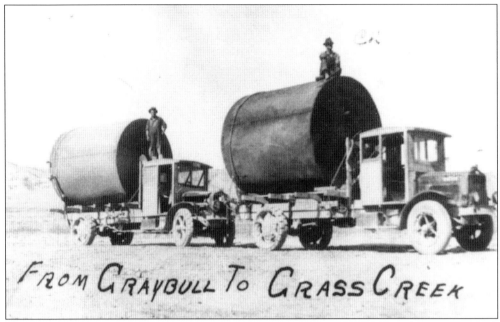

This 1920s photograph of tanks being hauled from Greybull, Wyoming, south to Grass Creek is from the C.L. Jones collection in the museum. Jones was a pioneer rancher, whose son Ralph worked in the oil and gas industry. The destination of these truckers and their cargo was originally named Midwest after the Midwest Refining Company, but the name was changed to Grass Creek to avoid confusion with another oil camp of Midwest, near Casper.

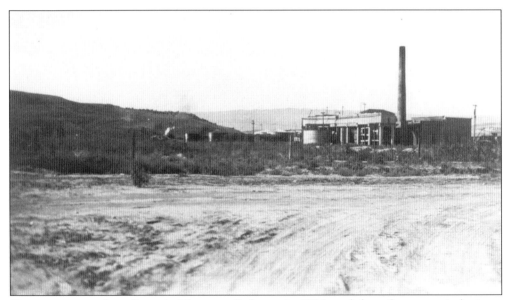

Construction on the refinery in Thermopolis began in 1916, and the refinery was in business into the 1950s. Despite a rocky beginning plagued with difficulties such as a refinery fire and a fuel administration moratorium on refinery building, by 1920 the Thermopolis refinery was handling 3,500 barrels a day.

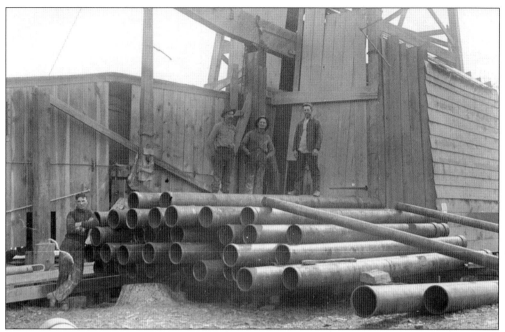

The location of this photograph has been tentatively identified as Well Number One at Hamilton Dome, to the west of Thermopolis, named for investor Dr. A.G. Hamilton. Four workers are posing casually with a huge stack of pipes at the base of a wooden drilling rig. Their clothing seems to be that of the 1910s, which fits with the Hamilton Dome identification, since the first well at Hamilton Dome came into production in July 1919.

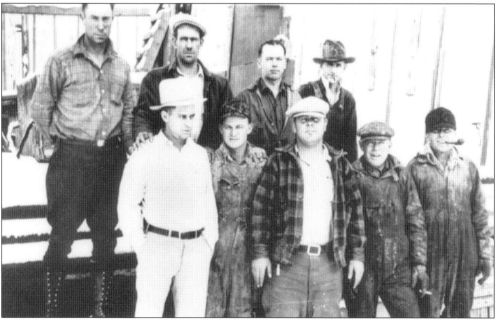

A slightly later drilling crew posed for a group portrait in this photograph from the C.L. Jones collection. Ralph Jones, C.L.'s son, is second from right in the back row. The man at the front left is wearing clothes hardly suited to oil-patch work. He is probably in management.

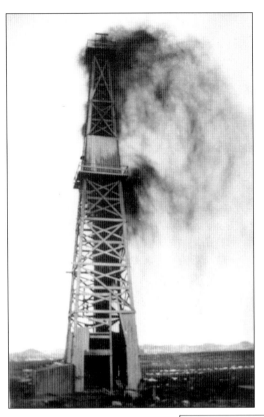

Another of C.L. Jones' photographs captures a gusher blowing out of a wooden rig, at an unknown location. Descriptions of area wells tell of gushers shooting to around 150 feet. In 1919 one investor at Hamilton Dome, "Mac" McCarthy, promised to roll in the oil if his men brought in a gusher. They did, a classic, and McCarthy cheerfully rolled in the oil in his Panama hat and good gray suit.

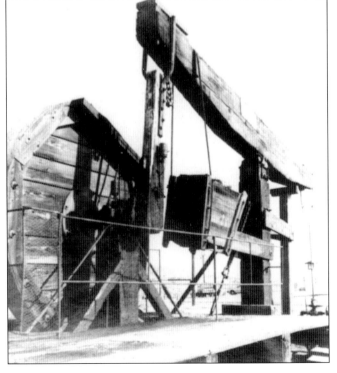

This photograph shows a pumping unit at work. The large wooden bull wheel to the left powers the pump, in the place of the pulleys and belts seen in more modern units. The beam at the top of the pump is known as a walking beam, for its up and down "walking" movement when the pump is in action.

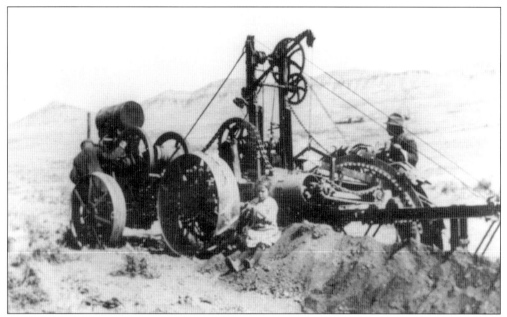

Minnian Richardson, a longtime resident of the Grass Creek area, assembled 33 volumes of scrapbooks on Grass Creek's history, which she donated to the Hot Springs County Museum for research purposes. This photograph from her collection shows Jerry Alsop operating a ditching machine; using the convenient pile of dirt as a location to work on her knitting is Rosalie McGee Taylor. (Courtesy of Minnian Richardson and John and Gay McGee.)

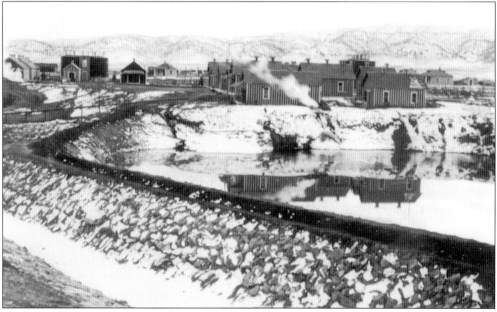

This striking winter scene shows the gasoline plant at Grass Creek. In 1929 when the Grass Creek pool hall burned, newspaper accounts reported that the attempts to save the pool hall failed because the fire hose from the gasoline plant wasn't long enough to reach the scene of the fire. (Courtesy of Minnian Richardson and Mrs. Burr Farr.)

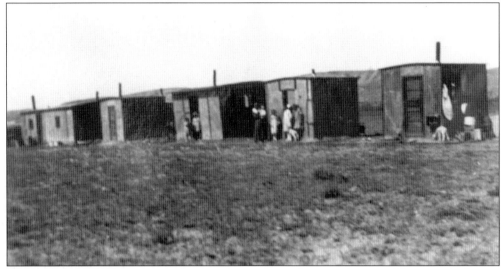

The oil boom brought new residents streaming into the area. Pioneer Thermopolis lawyer Clifford Axtell recalled signal fires being lit from hill to hill, to get claims filed before the competition. Leases often depended on whether wells were brought into production within a certain amount of time, and the process became a race. These dwellings at Drew Camp on Kirby Creek are typical of early oil camp housing, consisting of anything from tents to tarpaper shacks.

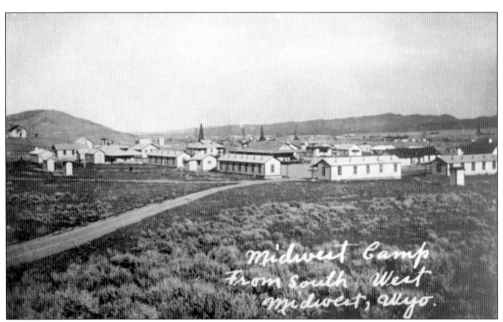

In contrast to the hastily constructed crackerboxes of Drew Camp is this idyllic village scene in a 1924 photo of Grass Creek, then still known as Midwest. If one didn't look closely, the spires in the distance might be taken for church towers, rather than oil rigs. (Courtesy of Minnian Richardson and Mrs. Burr Farr.)

This sinister-looking dark cloud does not indicate any disaster. The photograph, from 1918, shows waste oil being burned off a sump pit, which was a regular practice. (Courtesy of Minnian Richardson and Ruth Bennett Flanagan.)

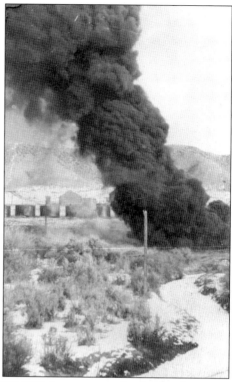

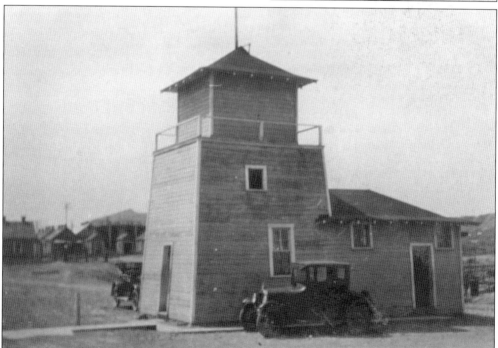

A variety of possible uses have been suggested for this unusual building at Grass Creek, from a church to a lookout tower. It is in fact the camp washroom and bath house. (Courtesy of Minnian Richardson and Max and Jackie Marcott.)

Ann Neese and an unidentified man, possibly her husband P.E. Neese, relax on the porch of the Ohio Oil Company's cookhouse at Grass Creek in the early 1920s. The Ohio's was the second cookhouse at Grass Creek, and sometimes fed as many as 500 men per day. On May 7, 1921, Ann Neese became the first witness on the scene of a bizarre crime. Rejected suitor Bert Lampitt blew up the camp's bunkhouse in order to kill his rival, Harry Foight. The explosion left Foight and his dog dead, along with another man named Worley Seaton. Lampitt's sensational trial had a change of venue to Basin, Wyoming. Lampitt was eventually sentenced to life in prison. The lady in the case moved to Kansas. In the aftermath of the explosion, the foundations and other remains of the shattered bunkhouse became some of the most photographed sights in Grass Creek. (Bunk house photograph courtesy of Minnian Richardson and Ruth Bennett Flanagan.)

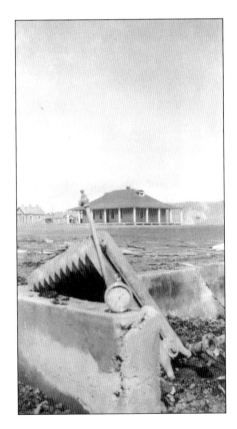

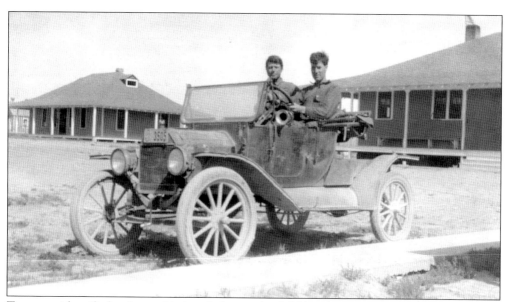

Two men identified only as a kitchen helper and a field hand pose in murderer Bert Lampitt's Ford, beside the foundations of the exploded bunkhouse. Lampitt's Ford was used as evidence against him, when an iron bar and a tire iron found inside the car were shown to exactly match dents on the powder magazine door, broken open to steal the dynamite used in the explosion. (Courtesy of Minnian Richardson and Ruth Bennett Flanagan.)

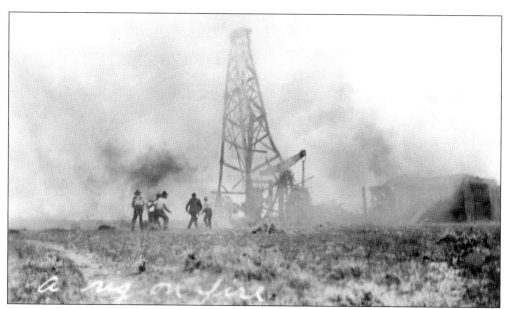

A more common form of disaster struck this Midwest Oil rig, captured on film burning and collapsing. The notes with the photograph state that the rig caught on fire at about 7:30 in the morning, when an unexpected flow of gas started coming in with the oil.

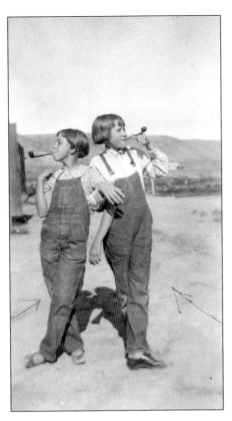

Grass Creek girls Elaine St. Clair and Dulcie Long posed with borrowed pipes for this photograph in the late 1920s or early 1930s. Elaine's father worked for Midwest Oil and later as a route mail carrier from Grass Creek to Kirby, and was one of the Hot Springs County Commissioners when he died in 1936 at age 45. (Courtesy of Minnian Richardson and Edna Gwynn Brome.)

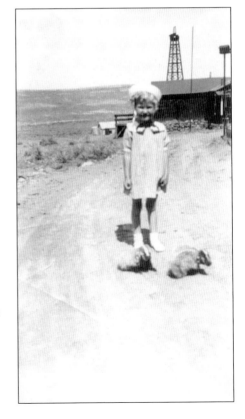

Another child of the oil camps, Joyce Hovey (later Haynes) posed with her pet badgers for this Hamilton Dome photograph around 1935. Joyce was of pioneer stock, her grandmother having arrived in the Hamilton Dome area by covered wagon from Nebraska in 1904. Joyce's family witnessed Hot Springs County's evolution from old west to new, from covered wagons to oil rigs.

Seven
THERMOPOLIS

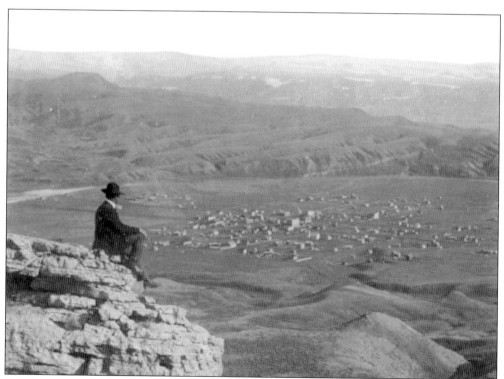

In this stereoscope picture that belonged to Minnie Brown, an unidentified man perches on Roundtop Mountain, gazing out over the new town of Thermopolis. Minnie's note on the picture dates it to 1905, when the town was eight years old.

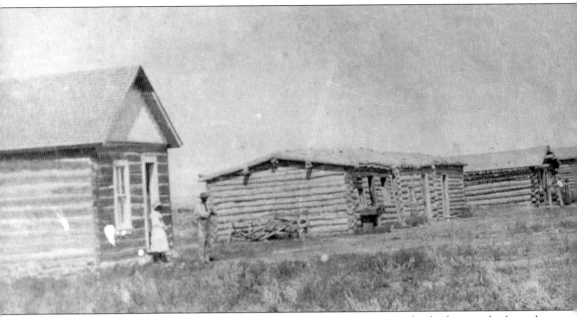

The first site of Thermopolis, founded around 1892, was about six miles further north along the Big Horn River from the current location of the town. Along with Andersonville, its neighbor across the river, "Old Town" Thermopolis provided support services for the tourists and health-seekers that came to the Hot Springs, then still part of the Wind River Reservation. Buildings in this photograph are identified as the Hansen home, Hansen's bunk house, the Higgins, Bird

Joe Magill, shown here in a snapshot probably taken at Old Town after it was abandoned, was one of the first schoolteachers in the Thermopolis area. With another early resident, Dr. Julius Schuelke, he shared the credit for coining the name Thermopolis.

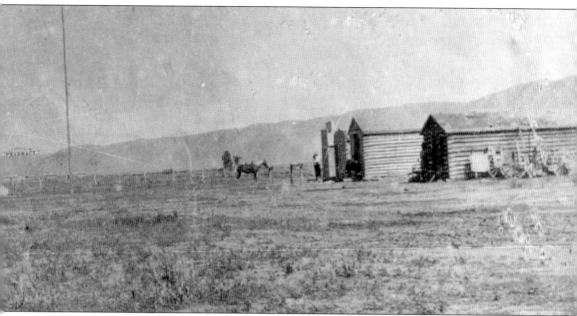

and McGrath general store, a butcher shop, E.C. Enderly's drug store and post office, J.P. Neilsen's blacksmith shop, Slane's barber shop, and Shafer and Cunningham's saloon. Individuals identified are Myrtle Stead, Ed Cameron, Ben Hansen, Thad Slane, J.P. Nielsen, and Al Hainer's horse.

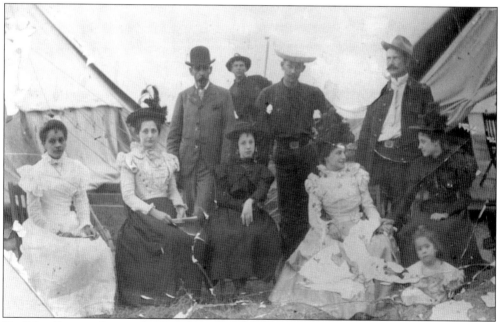

Dr. Schuelke, standing at the far right, posed for this picture at an army camp in Florida, during his service with Torrey's Rough Riders in the Spanish American War. Joe Magill was reputed to speak six languages, and Schuelke also had some Classical learning. When their town needed a name in order to obtain a post office, they created Thermopolis out of the Greek words for "hot" and "city".

Mr. and Mrs. Lyman B. Anderson, the couple pictured here, were of the pioneer family that gave its name to the short-lived burg of Andersonville. Members of the Anderson family remained influential in the Thermopolis area, with Charles W. Anderson, a brother of Lyman, becoming one of Hot Springs County's first county commissioners.

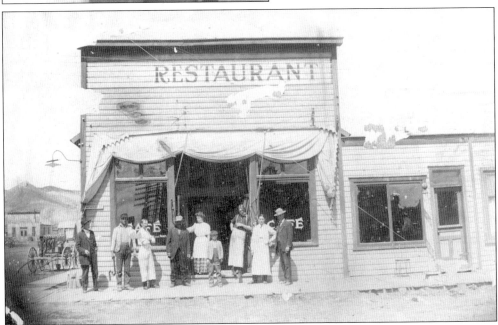

"New Town" Thermopolis came into being in 1897, after the Hot Springs treaty was ratified and the area around the springs opened for settlement. This café at the corner of Fifth and Arapahoe Streets, on the site of the current post office, is typical of early Thermopolis. The false front can still be seen on some buildings in the area, but the board sidewalks have long since vanished in the name of progress.

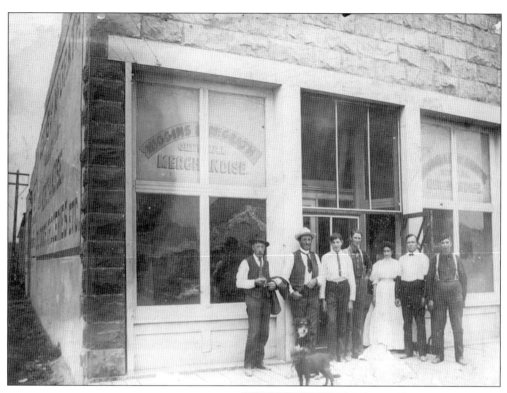

Outside Higgins and McGrath's store at Broadway and Fifth, stands Martin McGrath, second from the right, a leading businessman in early Thermopolis. The young man with the tie, third from left, is McGrath's stepson Ralph Barker, and the lady is Dora Barker McGrath, Martin's second wife. A civic leader in her own right, she founded the Hot Springs County Pioneer Association and the local American War Mothers, and was the first woman to serve in the Wyoming State Senate.

Looking almost too young to vote, let alone run for office, is Jim Martin, first mayor of Thermopolis. In this photograph taken probably in the 1890s, his wife is wearing a gown with a rather Ancient Greek flare to its draperies. Jim was elected mayor on February 4, 1899.

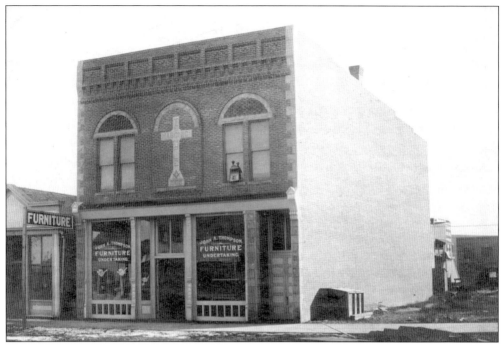

Among the most impressive of the substantial brick and locally quarried stone buildings that sprang up in the young town was the Masonic Temple at 521 Arapahoe, which still stands today. The Masons rented or donated space to various other organizations including the volunteer fire department, which had its headquarters in the back of the Masonic building in 1911.

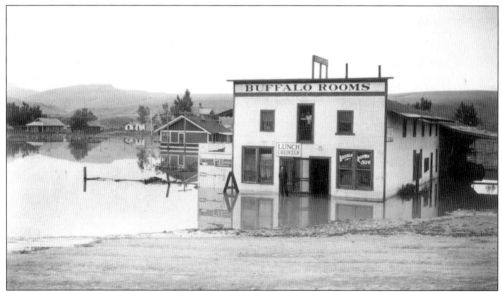

At least once a summer Thermopolis can still expect flash floods caused by rain run-off from the surrounding hills. In the days of more rudimentary drainage systems, the threat of damage was greater, from cloudbursts and suddenly swollen creeks and the Big Horn River. Here, in the Flood of 1923, is the Buffalo Rooms Café, long since vanished. The café stood just west of the train tracks on Broadway.

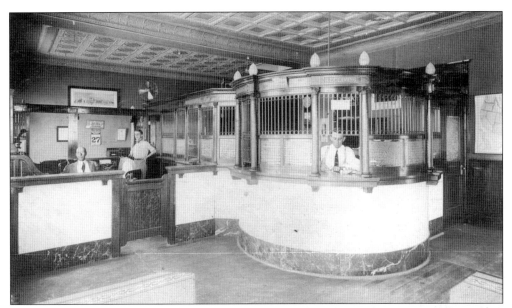

The First National Bank, shown here around 1913, stood on the southeast corner of Broadway and Fifth, at a hub of business and commerce. The four corners of that intersection housed three banks and Higgins and McGrath's General Store. Both the First National Bank building and the former home of Higgins and McGrath's were lost to fire in the 1980s.

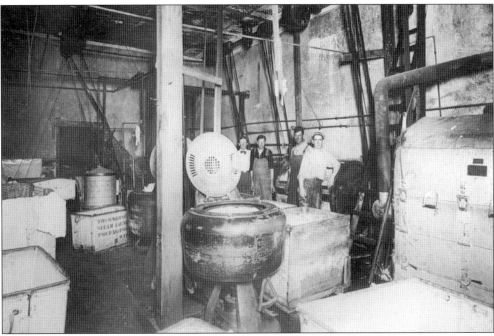

Pictured here is the back room of the Thermopolis Steam Laundry during the 1920s. The laundry was owned and operated by Ruth and Franklin Sande, from shortly after Franklin's return from World War I until his retirement in 1944. The building, at 528 Arapahoe, is one of the oldest-surviving native stone commercial buildings in Thermopolis. At the time of this publication it houses a Mexican restaurant.

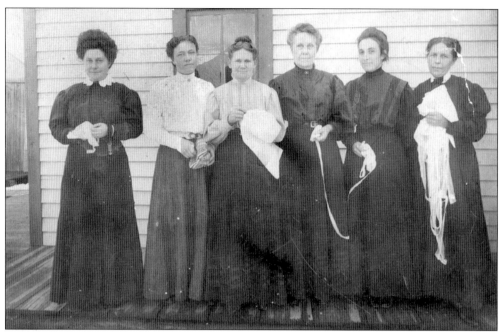

The ladies of the Sewing Club posed for a group photograph around 1910. Identified are Mrs. Dalzell, Mrs. Hans Hanson, Mrs. Shoop, Mrs. Sue Beals (fourth from left, wife of Ira Beals, first proprietor of the Pleasant View Sanitarium), and Mrs. Ewing. Unfortunately, one lady is unidentified, and the writer of the note with the photograph didn't state which woman was which.

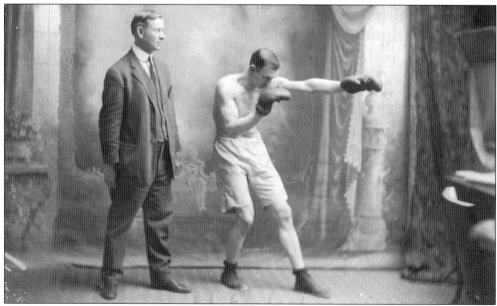

Pharmacist Ed Enderly demonstrates his boxing stance for an unidentified companion. The Enderly brothers owned a variety of businesses in both Old Town and new Thermopolis, including a hardware store, a post office, and a drug store. In 1894 Ed helped foil the robbery of Old Town's general store while the rest of the town was at the Thanksgiving Dance. He died in 1918 when a horse he was leading dragged him into a fence post.

Shown here, looking pleased with themselves, are the Thermopolis town baseball team of 1910–1911. In the front row are Mr. Jones of Gebo, Mr. Johnson, unidentified, Bill Stewart, and Bill Stilt. In the back row are Hosea Hantz, pitcher Dick Woodman, possible team manager Jack Hollywood, Guy Gay, unidentified, and Howard Collins.

The Thermopolis town band was photographed on Fifth Street in 1909. Behind them to the left is the First National Bank. Pictured here are, from left, W. Sisk, unidentified, Charlie Hett, Robert E. Martin, unidentified, W.M. Autin (band leader), Lon Thomas, Frank (Red) Smith, Basil Otey, Benny Weil, Frank Milek, Wesley Enderly, Arnold Duhig, and Frank McManigal. The little boy seated in front is identified as Roy Todd, band mascot.

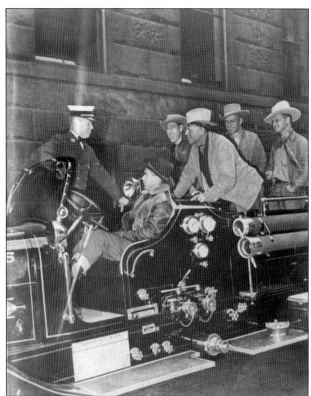

Thermopolis volunteer fire department members strike a pose in Cincinnati in 1937, where they took possession of the first pumper truck for Thermopolis. According to fire department records there were only seven of that model of Ahrens Fox trucks made. Pictured here are, from left to right, an unidentified representative of the Ahrens Fox Company, Carl Guggenheim, Thorp Thompson, Wilford Short, Wertz Hancock, and Ed Walsh. (Courtesy Steve Ehli and the Thermopolis Volunteer Fire Department.)

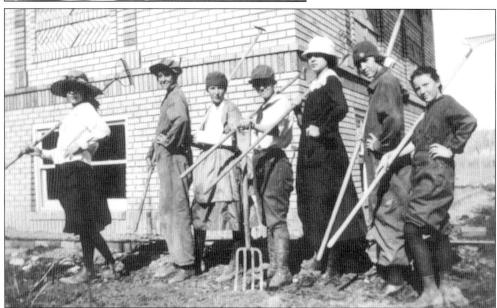

This photograph shows the Hot Springs County Camp Fire Girls, c. 1925. The girls are doing landscaping work outside the Carnegie Library. From left to right are Blanche Hicks, Marjorie Sisk, M. Smith, Susie Drake, Evelyn Hunter, Vera Jones, and June Garrison. The photograph was donated to the County Museum by Nellie Hodgson, who was an eighth-grade teacher and the adult leader for the Camp Fire Girls.

Pioneer newspaperman Arnold Duhig was photographed in the pressroom, working with trays of type. Duhig, also seen in the photograph of the town band, came to Wyoming in 1893 at age six, trailing a herd of sheep with his father Louis. In 1907 Arnold wed Thermopolis belle Jessie Cover. The Duhigs became a family of newspaper people, with Arnold as the youngest newspaper publisher in the country, and his wife and father joining him in the business.

Charles Hett, one of Duhig's fellow town band members, shows off his skill with the trumpet. Hett was a long time Postal Service employee and a well-known local musician, who had graduated as a member of one of Thermopolis' first high school classes.

Little Emerald Perkins, shown here in a portrait by a Sheridan, Wyoming, photographer, had the tragic distinction of being the second person buried in Thermopolis' Monument Hill Cemetery. She died of measles in 1898.

Another life cut off too short was that of Katheryn Skinner, whose mother Josie married saloon owner Tom Skinner. Katheryn appears later in this book as a member of the 1910–1911 Thermopolis High School girls' basketball team. This portrait of Katheryn as an "Indian princess" comes from the photograph album of long-time teacher and school superintendent Nellie Wales, who noted that Katheryn was an honor student in all school activities until her death in 1913.

This impressively-bearded gentleman is Reverend Louis C. Thompson, pioneer minister of the Big Horn Basin. Thompson built the first church in the Basin in Otto, in 1897. Two years later he founded Thermopolis' first church, the Methodist Episcopal Church at Sixth and Big Horn streets (later reorganized as the Community Federated Church, made up of Methodists and Presbyterians). Many stories were told of Thompson's frontier adventures, such as the time he met a fellow traveler on the road who exclaimed "Have you any idea what sort of job you're undertaking? There's a place in the Basin where if I was going to preach the Gospel, I'd carry my Bible in one hand and my six-shooter in the other!" Shown here behind the Methodist Episcopal church building is the fire department's bell tower.

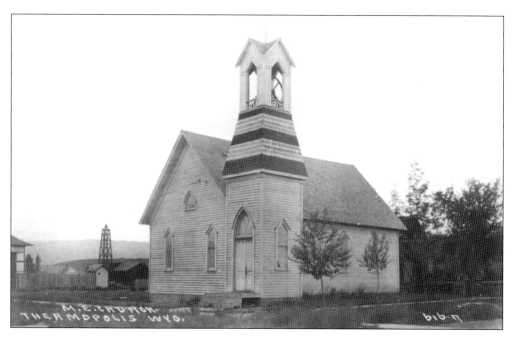

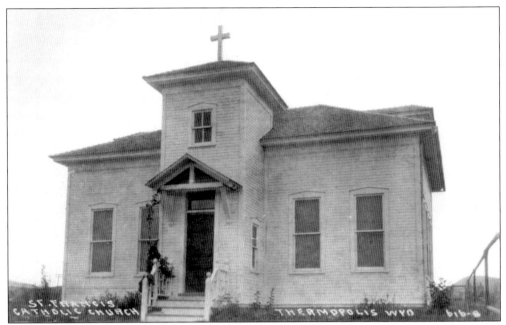

Another of the earliest Thermopolis churches was St. Francis Catholic Church, at the corner of Eighth and Arapahoe, the first Catholic Church in the Basin. Its first priest, Father Nicholas Endres from Belgium, arrived in Thermopolis in 1909 at the age of 27. Before St. Francis was built, Endres used the Town Hall and the Masonic Lodge as temporary churches, and had also preached in his boarding house room in Cody, saying Mass from a dresser.

Father Endres officiated at the funeral of popular schoolgirl Katheryn Skinner in 1913. Recalling his early days in Thermopolis, Endres wrote, "By railroad I was 1,000 miles from any headquarters, 200 miles from the next priest in the next state, here left to my own devices and resources. I was encompassed on all sides by mountains, and the impression it made on my mind was that I was at the end of the world."

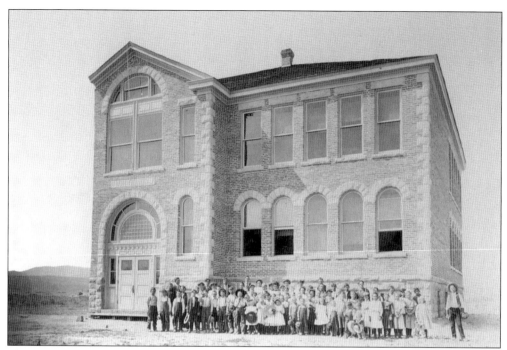

This 1904 photograph shows the Hill School, so-called for its imposing position on the hill above Broadway. Thermopolis children of all ages were educated in the school on the hill from 1901 through 1921. At the time of this photograph only half of the school had been built. Eventually a second wing on the other side of the entrance would mirror the half seen in this picture.

Ethel Anderson, Frank Maret, and Arlene Gaylor made up the first graduating class of Thermopolis High School. They were photographed in May of 1911 in their graduation finery. Ethel and Arlene were among the honored guests at the first all-school reunion held in 1971, but Mr. Maret was unable to attend.

These Thermopolis celebrities are the undefeated Thermopolis High School girls' basketball team of 1910–11. Identified are Bea Schnell, Minnie Cover, Myrtle Sherard, Ethel Anderson, Cora Hett, Essie Cover, Julia Sherard, Roda Holdredge, Bessie Burge, and Katheryn Skinner. Ethel, fourth from left, is one of the first three High School graduates, and at the far right is Katheryn, who would die only two years after this basketball team's undefeated season.

By the time this photograph of the high school track team was taken in the 1920s, the school had moved to its new location, across the Big Horn River from Hot Springs State Park. This track meet is being held across the street from the school, at the base of Elk (later "T") Hill.

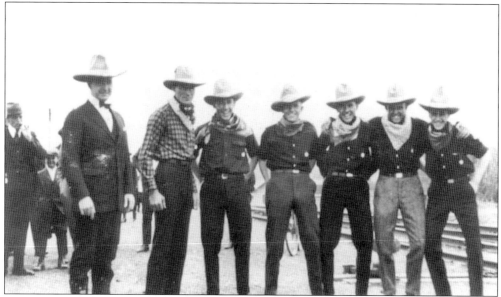

The track team's successes brought them adventure. When they took first place at the state track meet in 1922, they won a train trip to Chicago. The boys are photographed here about to leave for the Windy City, with Coach Horn (second from left) and Wyoming celebrity Tim McCoy, cowboy movie star and dude ranch owner. Team members, from left to right, are Ed Walsh, Burnett Noble, Wedge Thompson, Ralph Johnson, and Orba Teninty.

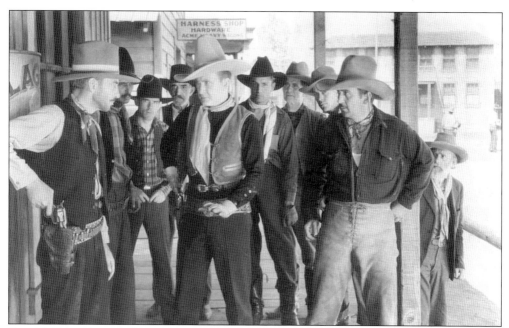

Tim McCoy, whose dude ranch was located west of Thermopolis, is shown here in one of his westerns, *Justice of the Range* (Columbia Pictures, 1935). Unsurprisingly, McCoy is wearing the white hat. Another local boy who made good in Hollywood was Bill Kellogg. Raised on ranches near Black Mountain and Grass Creek, he starred in *The Deerslayer* in 1943 and was married to opera singer Lucile Norman.

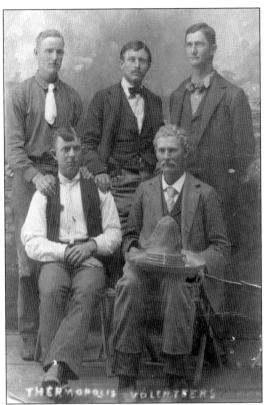

These "Thermopolis Volenteers" served in the Spanish American War. They were photographed at the Hot Springs Studio operated by A.K. Beckwith, in 1898. Pictured left to right are, seated, Thad Slane and Joe Humphrey, and standing, Bob Houston, Harry "Million Dollar Baby" Gunther, and Sam McDole. Humphrey's flashy sombrero raises the question of whether this photo was taken after the men's return from the war, or whether Humphrey thought it appropriate for an expedition to southern climes.

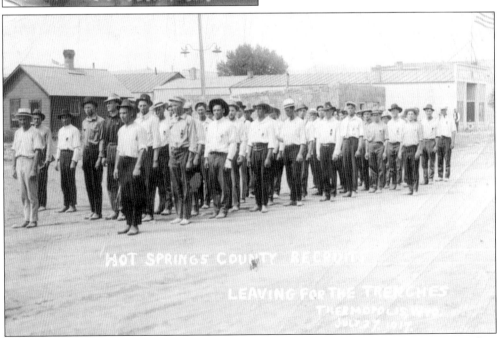

Nearly 20 years later, these Hot Springs County recruits were photographed on Arapahoe Street, on their way to the trenches of World War I. Seventy local boys applied to enlist in Company L, 3rd Wyoming National Guard Unit, in Thermopolis on July 27, 1917.

This earnest young infantryman is Reuben Harper, who served as Hot Springs County Assessor in the 1920s. A newspaper article written during his second term described him as "one of the leading spirits in civic affairs—a young man full of the vigor of youth." Harper's uniform seen in this photograph, consisting of hat, jacket, pants, and leggings, was donated by his brother John to the county museum.

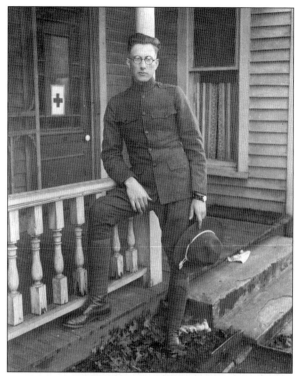

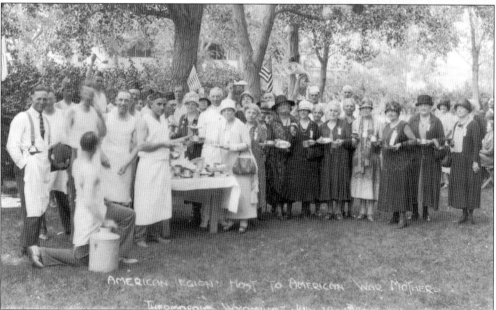

Dora McGrath founded the Godmothers' League, later reorganized as the Thermopolis chapter of the American War Mothers, on September 22, 1917. Among the Godmothers' charitable activities were organizing knitting classes for women who wanted to knit for the boys overseas, and conducting a fund drive to purchase tobacco for the soldiers. Here in July 1926 the American Legion boys show their appreciation by hosting a picnic for the Thermopolis War Mothers.

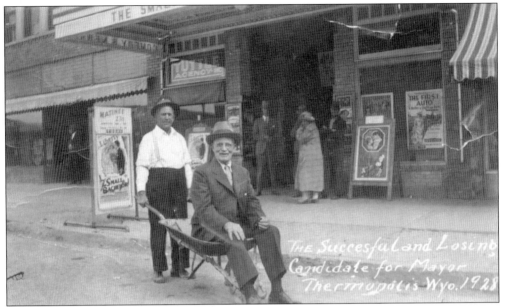

In this 1928 photograph, losing mayoral candidate Charles Hoofnagle gives his victorious opponent, Colonel George Sliney, a ceremonial ride in a wheelbarrow. They are in front of the Isis Theater on Broadway, later the Alhambra Theater, one of the many cinemas that flourished during Thermopolis' early decades. At the time of this publication, the former cinema building houses a restaurant.

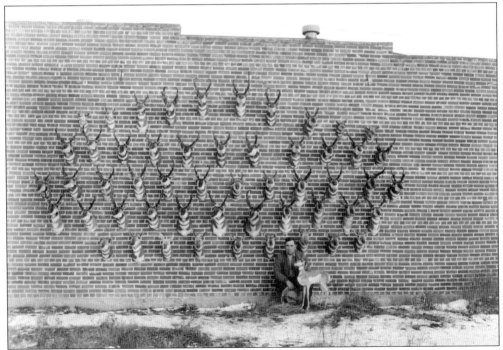

In the early days, just as now, Hot Springs County was a hunter's paradise. In this 1924 photo, Thermopolis taxidermist Bob Cole poses with a selection of his Pronghorn antelope mounts, displayed on one of the downtown Thermopolis buildings of locally made brick.

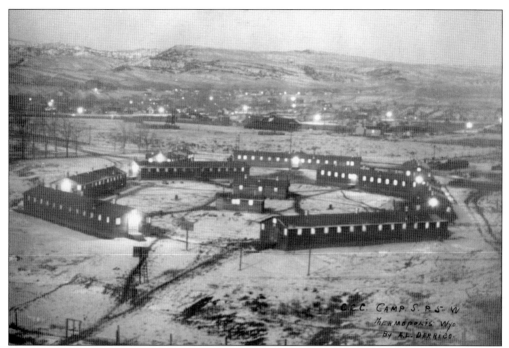

During the Depression years, the Civilian Conservation Corps had a large camp located on the Hot Springs County Fairgrounds on state park land. In the center background of this wintry scene is visible the fairgrounds' rodeo grandstand.

The Works Progress Administration Nursery was located in the spacious house that still stands at 624 Arapahoe Street. In the back right of the picture can be seen the bell tower of the Community Federated Church, with Elk/T Hill rising up behind it.

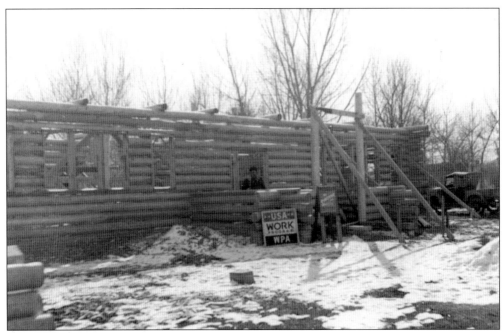

One of the projects through which the W.P.A. put Depression-era America back to work was the construction of the Hot Springs County Pioneer Museum, a goal that the Pioneer Association had worked toward for over a decade. The grand opening of the one-room log structure was July 4, 1941. Although the original building was torn down in 1977 to make way for a new elementary school, the pioneers' legacy lives on in today's Hot Springs County Museum.

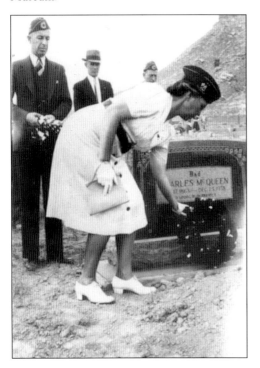

During the Monument Hill Cemetery Memorial Day services of 1939, Mary Kirby of the American Legion Auxiliary lays a wreath on the grave of rancher Charles "Dad" McQueen and his son Charles Ray, a World War I soldier who died of the flu epidemic in 1918. Less than four years after this photo was taken, Americans would once again be called to sacrifice with the nation's entry into World War II.

Ralph Barker was five years old when his father was murdered in Glenrock, Wyoming. Mrs. Barker and her children moved to Thermopolis, and two years later she married her widowed brother-in-law, Martin McGrath. They raised his two sons and her children, and had a daughter. Ralph became an active member of the Pioneer Association, which his mother had founded. The occasion of this "tough guy" photo of Ralph in his cowboy gear is unknown.

Alex Halone duded up for this Wild West photo after building a fireplace at Tim McCoy's ranch. Alex, a Finlander, was more at home wielding a crack hammer than a six-shooter: he was an expert stone mason. Halone's work can be seen in many structures around Thermopolis, including the home he built at 204 Amoretti. Due to the variety of stonework techniques displayed there, the house is on the National Register of Historic Places.

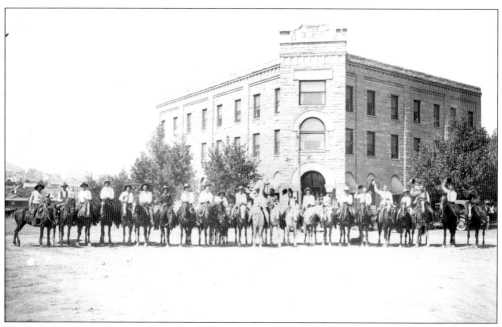

These rodeo cowboys were photographed on September 3, 1917, in front of Thermopolis rodeo headquarters the Emery Hotel, "Your Home on the Range." Alex Halone helped with the Emery's construction in 1906. On rodeo nights its horseshoe-shaped bar was jammed with celebrants, and the hotel was a major stopover for those traveling from Casper, Wyoming, to Billings, Montana. The classic structure was demolished in 1965.

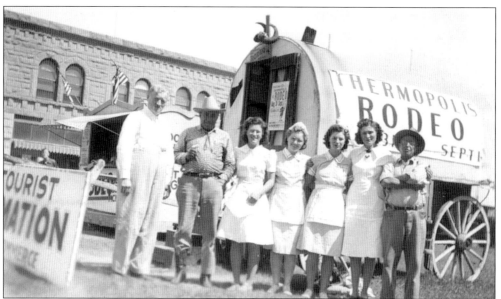

Ready for the Labor Day Rodeo, Thermopolis' biggest event for over 30 years, were, left to right: G. S. "Bert" Ogburn, owner and cook at the Sideboard Café 1922 to 1944; G.M. "Gyp" Hayek, teacher and later principal of the county high school and rodeo committeeman; Sideboard waitresses Nellie Vogt, Eddie Belle Purvis, Margie Franks, and Beulah E. Ogburn; and stockman Robert Richmond. The sheepwagon was the chamber of commerce office.

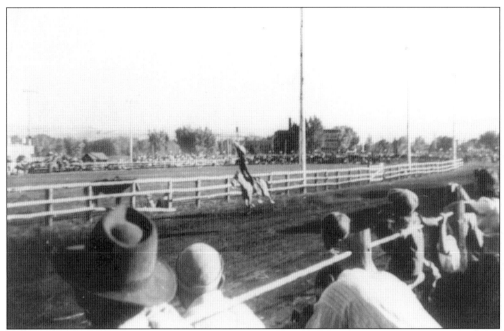

Petite Fay Knight, professional trick rider and member of the Gene Autry troupe, performs for the Thermopolis Rodeo in 1940. She and her husband Nick, a world champion bronc rider, owned and operated the Emery Hotel. Tragedy stalked the rodeo family. Nick and Fay were killed in a plane accident, Nick's brothers George and Tom died in an auto accident, and another brother, Jim, died of a heart attack.

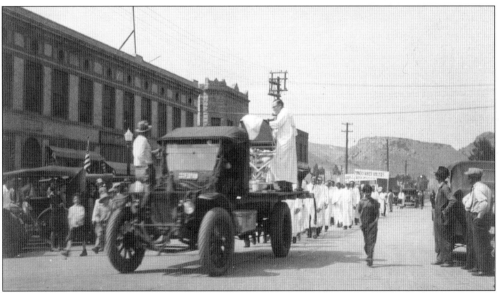

As this 1920s Labor Day parade winds its way south down Fifth Street to Broadway, Dr. C. Dana Carter "performs" an operation aboard his float. To the left in the background is the new Klink Building and next to it is one of the oldest buildings in town, the Herard Drug Store. After many years of neglect, it was restored by the law firm of Messenger and Jurovich. Eugene Halone, Alex's son, did the stone repointing.

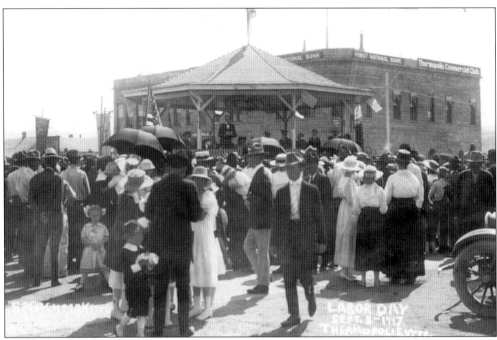

An unknown orator speaks at the 1917 Labor Day celebration. Note the little girl in the left of the photo. Her stance and facial expression make one think she would have been happier at home, barefoot, playing in a mud puddle. The bandstand in the Broadway and Fifth intersection was moved the next year to the city park on Arapahoe Street.

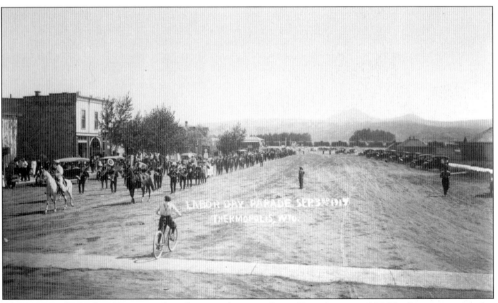

This view of a Labor Day parade taken to the east from Broadway and Fifth demonstrates the old and the new: the horses and horseless carriages, the edge of the old log Cover Café, the newer Virgin Hardware store next door, and Cover's new Broadway Hotel nearly hidden in the trees. Heralding in a new era are the train depot, the oil tankers on the railroad tracks, and a cement sidewalk.

Mike Goggles Jr., wearing his headdress, dancer bells, and a beaded belt with a typical Arapaho geometric design, and Nellie Sliney Rankin in her stylish riding habit, represent two cultures that were in bitter conflict only a generation before. Here both are ready for parade time in Thermopolis in the 1930s.

The old west met the new in Mac's Bar. Old-timer "Two Dog" Jack Scott shares a drink with Nadine Nostrum, left, and Jo Jones, right. Gone were the days when a lady would walk on the other side of the street to avoid going past a bar. Two Dog was a gold prospector, ranch hand, and wanderer who always brought his faithful sheep dogs to town with him. Nadine and Jo represent the settlers: Nadine, the granddaughter of widowed Amanda Nostrum who raised her large family by cooking for others, and Jo, the daughter of a Buffalo Creek rancher. This photo may have been taken when Nadine was Rodeo Queen in 1937.